GIRL TO GRRRL MANGA

How to Draw the Hottest Shoujo Manga

Colleen Doran

IMPACT
CINCINNATI, OHIO
www.impact-books.com

METRIC CONVERSION CHART

TO CONVERT	TO	MULTIPLY BY
Inches	Centimeters	2.54
Centimeters	Inches	0.4
Feet	Centimeters	30.5
Centimeters	Feet	0.03
Yards	Meters	0.9
Meters	Yards	1.1

11 10 09 08 07 5 4 3 2 1

DISTRIBUTED IN CANADA BY FRASER DIRECT
100 Armstrong Avenue
Georgetown, ON, Canada L7G 5S4
Tel: (905) 877-4411

DISTRIBUTED IN THE U.K. AND EUROPE BY DAVID & CHARLES
Brunel House, Newton Abbot, Devon, TQ12 4PU, England
Tel: (+44) 1626 323200, Fax: (+44) 1626 323319
Email: mail@davidandcharles.co.uk

DISTRIBUTED IN AUSTRALIA BY CAPRICORN LINK
P.O. Box 704, S. Windsor NSW, 2756 Australia
Tel: (02) 4577-3555

Library of Congress Cataloging in Publication Data
Doran, Colleen
 Girl to grrrl manga : how to draw the hottest shoujo manga / Colleen Doran.
 p. cm.
 Includes index.
 ISBN-13: 978-1-58180-809-4 (pbk. : alk. paper)
 ISBN-10: 1-58180-809-7 (pbk. : alk. paper)
 1. Girls in art--Juvenile literature. 2. Comic books, strips, etc.--Japan--Technique--Juvenile literature. 3. Cartooning--Technique--Juvenile literature. I. Title.
 NC1764.8.G57D67 2007
 741.5'1--dc22 2006018171

Edited by Mona Michael
Designed by Wendy Dunning
Page layout by Sandy Kent
Production coordinated by Mark Griffin

About the Author

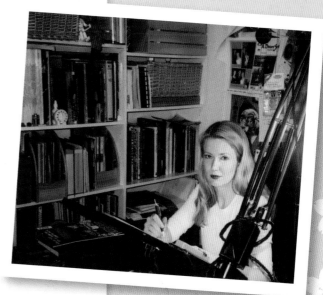

After winning a contest sponsored by the Walt Disney Company at the age of five, Colleen Doran avidly pursued her goal of becoming a professional cartoonist, landing her first commercial work at age fifteen. To do that, she studied a lot of books just like the one she wrote and drew for you here! It is her hope to give young creators the kind of inspiration and enjoyment she has been lucky enough to experience.

Colleen has more than five hundred credits as an artist, writer and designer. She has worked as a consultant for Japanese companies like Bandai, providing information about bringing manga to the USA. She participated in the U.S./Japan Manga Seminar sponsored by Tezuka Productions in Tokyo, Japan, and lectured about manga at the American Library Association. She was also chosen to be artist-in-residence at the Smithsonian Institution to lecture on the work of Hokusai's ukiyo-e prints and their relation to modern manga and graphic arts.

Colleen's series for Image Comics, *A Distant Soil*, is possibly the first graphic novel series solely written and illustrated by a woman in the USA. She has also worked on projects like Neil Gaiman's *Sandman*, and is the artist of *The Book of Lost Souls* by *Babylon 5* television series creator J. Michael Straczynski, currently published by Marvel Comics' Icon line.

In her very rare spare time, she enjoys her favorite manga and is very happy to see so much of it now in English, so she can actually read it.

Acknowledgments

Special thanks as always to my mother and assistant Anita Doran. Also, I send my love to my father for his support. I am grateful to my very decorative models Jarl Benzon, Sandro Kopp and Kacey Camp. Also, I must thank my editor, Mona Michael, and publisher, IMPACT Books, for their patience and understanding. As always, my warmest thanks to all of the fans who have given me so much of their energy and enthusiasm.

Dedication

For Takeyuki Matsutani and everyone at Tezuka Productions.

Also, warm thanks to Fred Schodt and to my idol, Riyoko Ikeda.

Also, to Leslie Sternbergh for introducing me to Japanese comics.

TABLE OF CONTENTS

Introduction 6
How to Use This Book 8
What you Need 10
Your Most Important Tools 12
Resources 125
Index 126

1 DRAWING THE SHOUJO FACE AND FORM 14

Two of the most important aspects to shoujo characters are the head and face. Use simple shapes and forms to create the shoujo-style necessities.

2 ABSOLUTELY FABULOUS: FASHION AND STYLE 64

Look here for simple tricks to creating the special details of shoujo manga including clothes, hair and other fun frills!

3 THE SHOUJO STYLES 90

Explore drawing in the different shoujo styles: classic, retro, children's aesthetic, modern and illustrative. There is more than one look in shoujo manga, and you can even create your own.

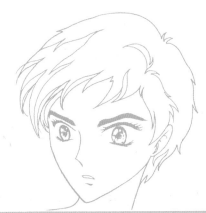

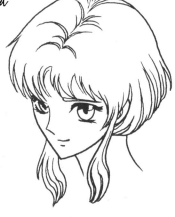

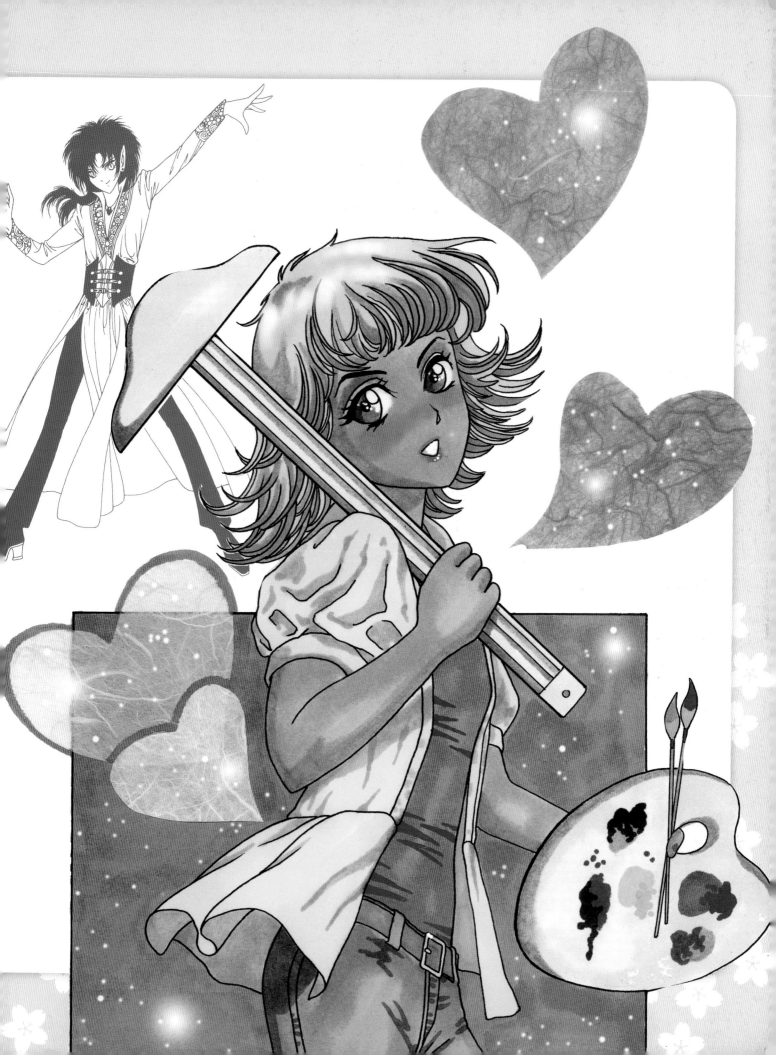

INTRODUCTION

Have you ever had a dream like this?

You love manga, especially shoujo manga, the dramatic and glamorous world of Japanese girls' comics. Maybe you've never been to art school and don't have a lot of training, but you yearn to draw, and you have great story ideas. So, you put a few pages of your own story together and make copies, passing them around to friends and anyone you meet. Then, using your home computer, you post your new story on the Internet, or even send it to friends using your home mobile phone. Your friends pass it to their friends, and they pass it on to their friends.

Suddenly thousands of people are reading your stories and seeing your art! One day, a publisher sees your work and decides to put your story into print. The next thing you know, you have a great publishing contract and lots of fans. Your book is a big hit. And then, your book is signed to a movie contract. You are now a superstar cartoonist!

It sounds like fantasy, but it is the true story of the Japanese artist Yoshi, whose comic *Deep Love* was created exactly this way. American fans of manga are also going on the Internet and publishing their own comics, or answering talent search calls from major publishing companies. Some of them have seen their *OELs* (Original English Language manga) go on to become hit books! With dedication and enthusiasm, aspiring artists who have lively stories and entertaining art are real-izing their dreams, even though they may not have gone to important, expensive art schools.

I am also one of those artists. I got most of my training at home by read-ing books like the one you are holding now. When I was growing up, I bought as many how-to books as I could get my hands on and drew every day. I had my first professional art contract by the time I was fifteen years old. I also love shoujo manga, so I am going to share with you some of what I have learned in hopes that you, too, will be able to enjoy the thrill of drawing your own manga art.

Shoujo manga is an especially important part of the comics scene now because for the first time in decades, girls and women are getting

The interior of the Osamu Tezuka Manga Museum in Takarazuka, Japan, reflects the whimsical style of the artist himself.

I was invited to Japan as a guest of Tezuka Produc-tions for the U.S. Manga seminar in Tokyo, Japan. American artists like me were thrilled to meet other *manga-ka* (the Japanese word for cartoonist).

Here, Mr. Takeyuki Matsutani, president of Tezuka Productions, stands in front of a portrait of the "God of Comics," Osamu Tezuka. Tezuka had no formal art training when he hit it big.

an opportunity to read comics created by or for them! For many years, especially in America, there were few comics either created by women or for female readers. American comics companies generally concentrated on action and superhero tales that young boys favored. Of course, girls read superheroes, too. But the dramas, romances and fantasy tales that were so common in Japanese comics were almost unknown in the West.

In fact, it's only been a little over a decade that shoujo manga has really begun to make inroads into the American comics scene. In that short time, they have become the most popular form of manga! Over 60 percent of manga readers are women and girls, and female enrollment at comic art classes and schools has seen a huge jump! Shoujo manga's beauty, drama and variety appeal to all kinds of people, girls and boys alike. Some 35 percent of all manga published in Japan are shoujo manga.

The term *shoujo manga* is usually used in the West to refer to all comics intended for female readers. However, it has a slightly different meaning in Japan. *Shoujo manga* in Japan refers specifically to comics intended for girls between the ages of eight and eighteen. Other terms describe manga for a variety of readers such as *josei manga* (adult women's comics) and *kodomo manga* (comics for girls below the age of eight). We'll use the term *shoujo manga* for the purposes of this book at all times.

The shoujo manga that made the biggest splash and revolutionized the genre was Osamu Tezuka's *Ribon no Kishi* (Princess Knight).

Ribon no Kishi first appeared in 1953, the story of a girl who is born to a king and queen who must have a male heir. The Princess Knight must masquerade as a boy to save the kingdom and has many daring adventures, all avoiding the attempts of pretenders to the throne desperate to prove she is a girl and unfit to be the heir.

Osamu Tezuka is revered as the "God of Comics," and is one of Japan's most famous figures. Unlike earlier manga artists who concentrated on panel gags and short stories of a few pages each, Tezuka created epic tales with sweeping cinematic scope of the kind that dominate manga today.

Tezuka's art was based heavily on Walt Disney's early animation technique, and the huge eyes and cartoonish designs harkened back to those Disney films that Tezuka had seen as a boy. Large eyes and childlike features still dominate the shoujo manga style, but now many other looks appear in shoujo art as well. Of course, manga have a huge influence on American comics and animation today, too. In fact, Walt Disney's *The Lion King* owes a great debt to Osamu Tezuka's manga/anime masterpiece *Kimba the White Lion*.

With its emphasis on emotion and mood, impressionistic storytelling techniques, decorative costume design and dreamlike settings, shoujo manga's unique appeal has inspired many artists outside of Japan to create their own works.

This book was written for you! Let's go!

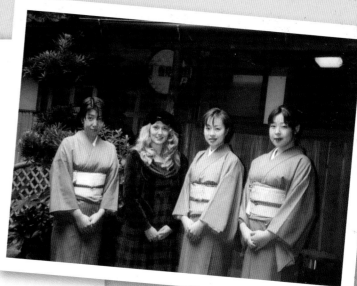

I learned to draw and paint using books much like the one you are holding now. My interest in shoujo manga brought me to Japan where I visited a *ryokan* (traditional Japanese inn) with these lovely kimono-clad ladies.

HOW TO USE THIS BOOK

This book is a little different from other how-to-draw books. I have drawn all of the art in this book myself. Other manga how-to books often employ a team of artists to get different kinds of looks. But I am only one person, and while I am not going to teach you to draw everything in the world in only 128 pages (as if that is possible), I am going to teach you what you need to know about one thing: shoujo style. You'll learn how one artist can create a variety of looks. And if I can do it, you can do it, too!

You won't find any long chapters on how to draw buildings or cars or anything like that. Have you ever wondered how to draw like CLAMP or Mineo Maya or Fuyumi Soryo? This is the place for you. Here, you will learn to do just that. You will learn to analyze and duplicate the underlying structure of several kinds of shoujo looks. You will learn how to draw characters (the most important thing in shoujo) and emotion, and how to create mood with pictures.

A couple of other items of note before we begin:

* This book was created with the beginner to intermediate western artist in mind. Some of the things we will address are commonly known to Japanese, but not so familiar to others.

* Also, some of these drawings may be a little simpler than manga drawings usually are. This is to help you see the underlying forms beneath the detail you may be accustomed to seeing in manga. Get comfortable drawing the underlying forms before you move on to more complex work. If the underlying forms are not well drawn, no matter how much detail you add to your picture you will not be able to cover up its flaws. Simple things are important. Start simple and build from there.

ILLUSTRATION FOR *MEANWHILE*

WHAT YOU NEED

When I was a little girl, we couldn't afford expensive computer programs or equipment—no pose programs for helping out with my figure drawing, no computer scans of photos for my backgrounds. In some ways, that was good for me because not having fancy tools meant I had to learn to get results the old-fashioned way, which is often better for training artists. You can achieve professional quality results with simple tools. That's one of the advantages to drawing manga! You can draw it anywhere with little equipment. The tools used in this book are limited to things that almost anyone can afford to buy.

Pencils and erasers. Use whatever works best for you. Just remember that the harder the lead, the lighter your line. I prefer mechanical pencils. You can buy them in a wide variety of styles that suit the shape of your hand.

Pens. Many different kinds of dip pens and technical pens are sold in most art and hobby shops. Manga artists usually use a type of *crow quill* pen (traditional pens with metal nibs) called the *G-pen*. You can get it at online manga and art supply stores. I use Deleter markers, also commonly used by manga artists. They come in a variety of point sizes and are equally useful for fine figure work or difficult technical drawing.

Ink. Higgins Black Magic ink is the industry standard for most western artists, but I prefer Japanese-made ink. The most important thing to remember about ink is that it must be permanent and waterproof.

Brushes. Some artists do almost all of their inking with brushes, and some artists, like me, use them only for filling in large areas or making corrections. The ones I used to work on this book came in an inexpensive craft set. If you do a lot of your inking with brushes, you will need to get the best quality you can afford and take good care of them. Do not leave them sitting in the water you used to clean them!

Markers. Look for markers that are *nonbleeding*, or your lines will look fuzzy when you draw them; *permanent*, or in a few years your ink will start to fade and your black lines may turn gray or green; and *waterproof*. Nonwaterproof marker lines will rub away from having your hand brush across them when you work, to say nothing of what will happen to the ink when you try to use correction fluid on them.

Pencils and Erasers
Keep several pencils with different lead weights around. A sandpaper block for sharpening the tip is another handy item. All kinds of erasers are available for different needs. Keep several types on hand.

Brushes
Never use the brush you use for inking for anything else. Use a separate brush for corrections, and never use either of those brushes for painting.

Paper. Always buy acid-free paper. Have you ever looked at an old book or newspaper that is turning yellow and brittle? That is what happens to cheap paper that is not acid free. I use a Bienfang drawing Bristol, 146-lb. (307gsm), with a fine surface. For painting, I use a Strathmore series 500 5-ply Bristol. There are also sketchbooks and layout papers made just for comics art.

Correction fluid. This is also vitally important. It is not only for cleaning up goofs, but you can use it to get a lot of cool effects such as painting highlights onto eyes or creating snow and rain.

OTHER TOOLS

A few more items and you have a basic studio set up!

- Ruler
- T-square
- Templates
- Files
- Clean cloths or paper towels
- Trash bin (A messy studio is a nightmare.)
- Water jar for cleaning brushes
- Camera for taking reference pictures
- Portfolio or bag to store your art supplies

Portfolio

This little bag is no more than 4 inches (10cm) thick and 17 inches (43cm) wide when closed, but it's huge when open, large enough to carry your tools, and it even has files built in! If you have limited space at home, most of your work can fit in here. This is not a standard art portfolio. It's a bag for crafters who do scrapbooking. It is not only less expensive than a portfolio, it also has more pockets and features. You can find one at many discount and craft stores.

Markers and Pens

Felt-tip markers are a popular tool for manga artists because they produce fast, colorful results. Using a "blender" marker, the colors can be melded together so they look almost as smooth as paint. Professional quality markers are quite expensive. I used them in this book. But for practice, you can find less expensive alternatives. If you can't afford a good-quality marker set all at once, you can buy individual pro-style markers. Look for permanent, lightfast markers (many markers also fade in sunlight). Protect your finished art by framing it under UV protective glass or spraying with UV protective film.

Paper

Don't skimp on paper. Acid-free paper may cost a little more per pack, but if you want to be able to enjoy your drawings years from now, you must invest in better paper.

Templates

For ruling perfect edges, a set of templates is very handy. You just lay them down on your paper and run your pen along the inside of the shape to get perfect circles or other forms.

The most amazing secret you will ever learn about drawing is right here. Ready? If you can draw a circle, square, triangle and a cylinder, you are well on your way to successful art! Almost everything you will ever draw in your life is composed of variations of these simple elements.

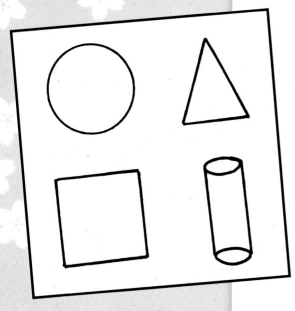

Circle, Square, Triangle, Cylinder
That's right. These simple shapes compose the foundation of almost every conceivable form. Start right now practicing with them.

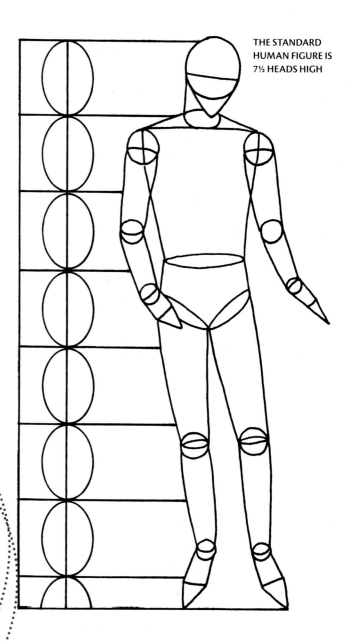

THE STANDARD HUMAN FIGURE IS 7½ HEADS HIGH

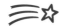

GIRL TO GRRRL TIP

Take a few photos of family and friends and tape them on a sunny window. Tape a thin sheet of paper over the photo. If the window is bright, you should be able to see right through the paper to the photo image. Using a pencil, draw the mannequin shapes of the figures in the photos by tracing the outlines of the forms and filling in the basic shapes. This will help you see the simple forms that compose the human figure.

All Figures Consist of Basic Shapes
The basic building blocks of the human body are exactly the same whether drawing a manga figure or a realistic, academic-style drawing. Look for the simple shapes underneath whatever you draw. If you can master simplicity, you can create more complex drawings.

THE FACE MAKES IT MANGA

The manga figure is much taller and thinner than the standard human figure. It averages about 8½ heads high, but can be drawn 12 heads high or more!

However, barring height and the head, these two figures have a lot in common. If you were to switch their heads, the drawings would still work! The most easily recognizable aspect of manga style is the face. We're going to spend a lot of time getting the faces right later on.

Standard Comic Figure
Underneath the folds of the clothes and the muscles, this guy's framework is not much different than that of the mannequin (left). The proportions are the same.

Manga Figure
Compare to our manga figure here. Adult manga figures are rarely shorter than 8 heads. Also, he is much thinner and the longer lines give him an elegant look. But underneath all that, the mannequin shape is still there.

Drawing the SHOUJO FACE and FORM

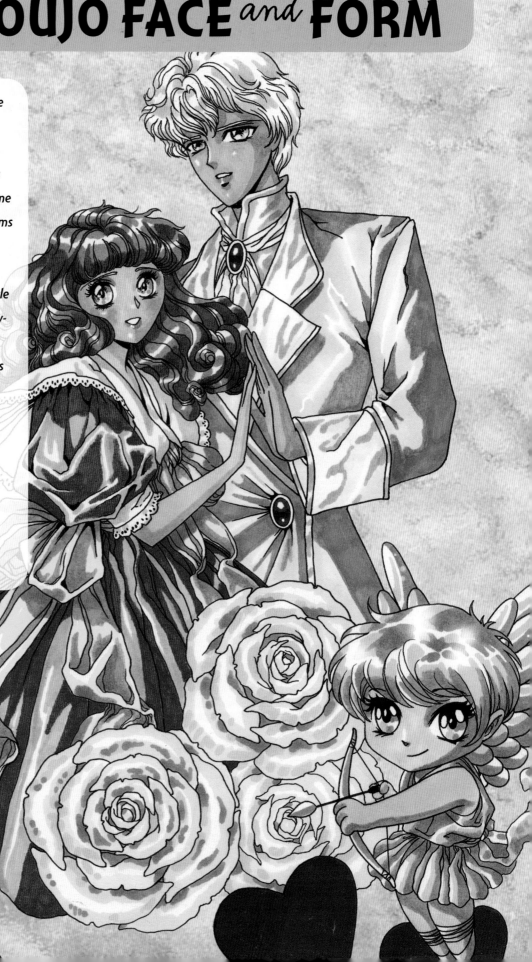

Nothing says shoujo like the beautiful and glamorous people manga artists draw. As you have already seen, all types of drawing are based on the same principles: breaking complex forms down into easy, simple shapes.

The popular contemporary look in this illustration is the style we will use for many of our drawings in this chapter. It is easy to master, and many manga artists favor it. You can draw any type of story in this style—romance, drama, historical, teen angst—you name it. Its versatility and popularity make it the perfect style to practice your first time out!

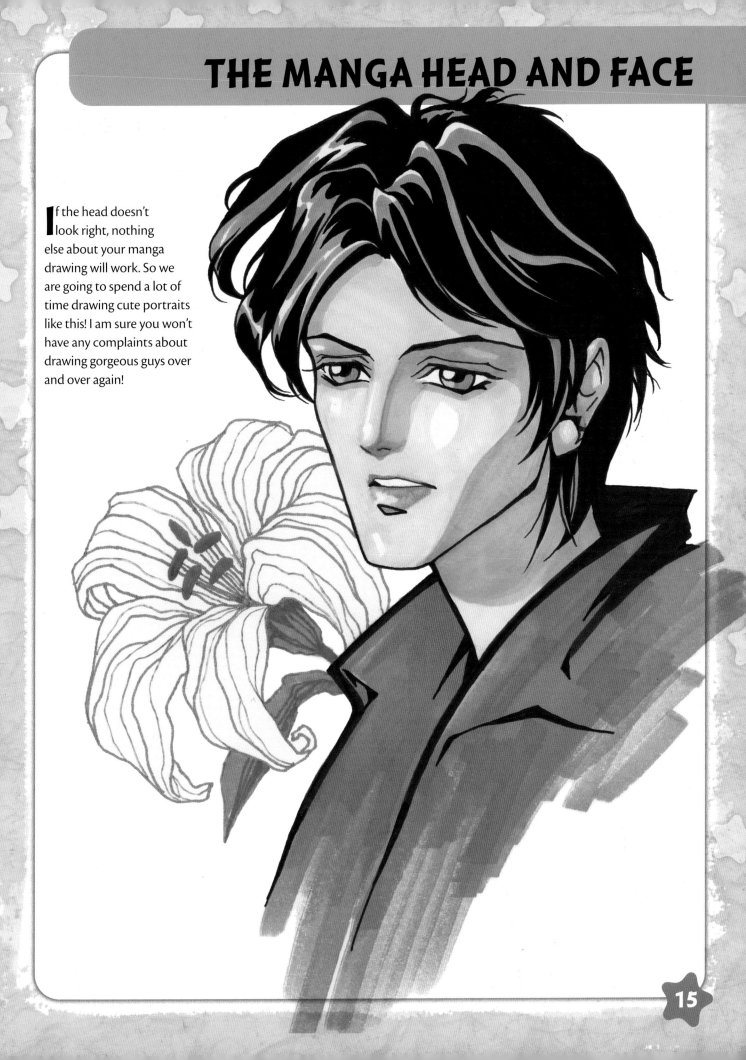

If the head doesn't look right, nothing else about your manga drawing will work. So we are going to spend a lot of time drawing cute portraits like this! I am sure you won't have any complaints about drawing gorgeous guys over and over again!

Basic Head Construction

Drawing the manga head is all about knowing how to fit basic forms onto a simple circle and triangle shape. Start by comparing the standard academic style of drawing with the manga style. Academic drawing is the kind of formal drawing taught in art schools, the kind used to draw realistic-looking people. You will learn some of these academic techniques throughout this book. They come in handy when drawing manga, too!

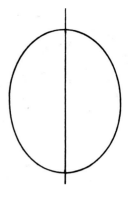

The Realistic Head Shape
OK, you're looking at it. A simple oval shape is all you need as the basis for the standard human head. Taper the oval at the chin end. If you have trouble getting a good oval, you can use a template to trace it.

Can you spot even more differences?

More important than the differences are the similarities. The basic tools used to construct both types of heads are **_virtually the same_**!

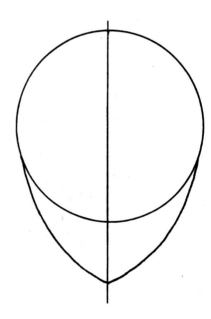

The Shoujo Head
Draw a far more exaggerated oval shape. Draw it as a circle and attach a slightly curved triangle to its lower third. The point of the triangle should be in the center.

The head is about 5 eyes wide.

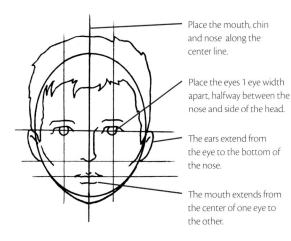

Place the mouth, chin and nose along the center line.

Place the eyes 1 eye width apart, halfway between the nose and side of the head.

The ears extend from the eye to the bottom of the nose.

The mouth extends from the center of one eye to the other.

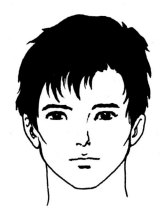

2 Begin Details
Taper the oval and begin to add features. Give some shape to the chin. Follow the callouts to place the features.

3 The Realistic Finish
To finish off your "realistic" head, carve out a bit of the oval to get cheekbones and a jaw. Refine the features, and this is a pretty attractive guy!

The head is only about 3 eyes wide.

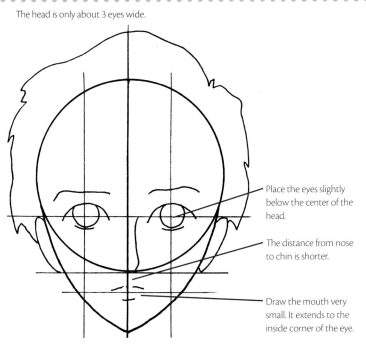

Place the eyes slightly below the center of the head.

The distance from nose to chin is shorter.

Draw the mouth very small. It extends to the inside corner of the eye.

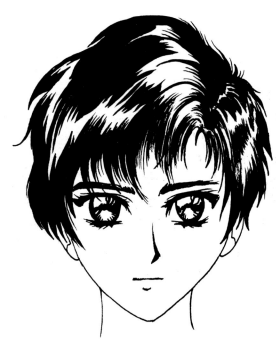

2 Begin Details
Using a circle instead of an oval makes for an incredibly prominent cranium! Those big eyes have to fit in there somehow! The manga cranium is almost always quite large. And the big eyes and small chin give the face a more delicate appearance.

3 The Shoujo Finish
See the big difference a few details make! Underneath all this hair and those big eyes is very simple construction that isn't much different than the more realistic head you have drawn. The shoujo cranium is larger, the chin is more pointed, the jawline is less square and the eyes are easily four times as large as a normal human eye. You get big results from these little differences! Take the time to draw these basic forms over and over. Get used to building the head from these simple steps.

Small Changes, Big Differences

S o now you know the secret of the circle and triangle. These manga heads show how just a few simple changes in the circle/triangle combination make for big differences in the shoujo head. These shapes are usually used for adult men and women or older teens.

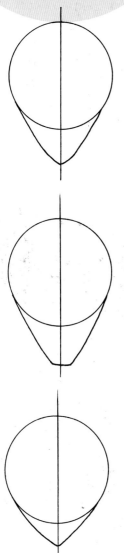

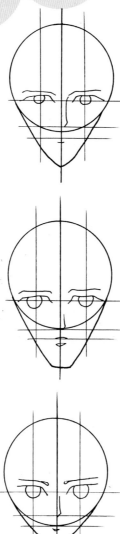

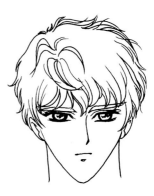

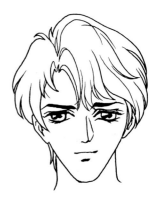

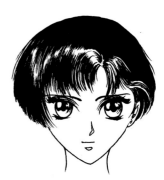

1 Use your template to draw three circles. If you're feeling bold, draw them freehand. Draw a line directly through the center of each circle. Extend two curved lines that meet at the point below the center. There's a lot of variety in chin shapes.

2 Here's where you have some fun! Copy these sketches or try some of your own. Move the features up and down, widen the eyes and play with the shape of the mouth. Notice how each head has different eye shapes. Some of the eyes are higher on the face than others.

3 All these faces are in different shoujo styles, but all use the same basic building blocks. The length of the chin and width of the eyes completely change the character of the face, yet the shapes underneath the sketches are incredibly simple to draw.

This is why it's important to practice drawing the basic structure of the head. Like the famous Japanese tea ceremony, it looks simple, but simple things are important!

TRY SOME MORE!

These shapes are more often used for girls and boys or very young children.

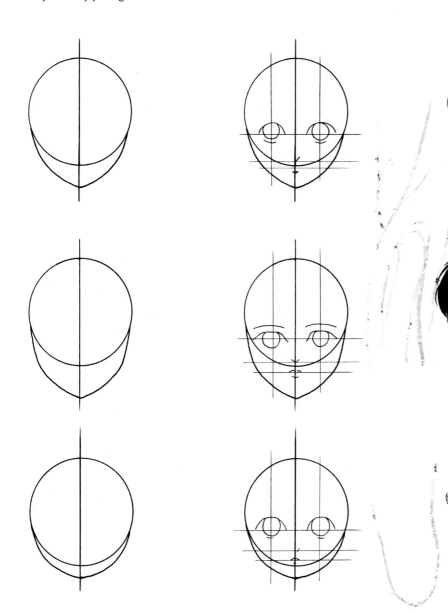

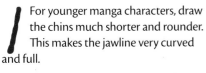 For younger manga characters, draw the chins much shorter and rounder. This makes the jawline very curved and full.

2 Children's eyes are larger in proportion to their heads and their eyes are set lower in the head. Place them at the point where the jawline triangle meets the head circle. Since the jaw is shorter, the distance between the mouth and chin is also shorter. Make sure their faces remain more rounded.

3 These examples show, yet again, what a huge difference the basic head structure makes in the shoujo head. Your basic building blocks won't change, but how you use them changes everything. Underneath every complex drawing is a simple structure.

Nothing captures the shoujo manga look like big, luminous eyes. Large eyes are infinitely expressive and drawing them well will go a long way toward making your art look appealing. Eyes are very easy to draw in a variety of shapes and styles.

To draw the manga eye at its best, we need to take a moment to study construction of the real human eye.

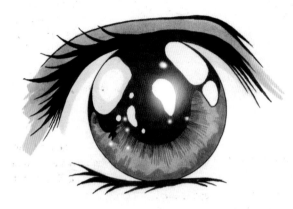
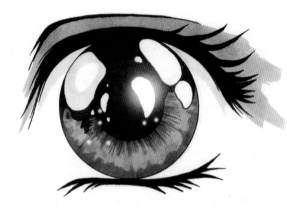

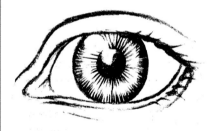
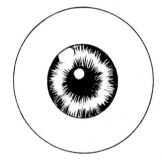
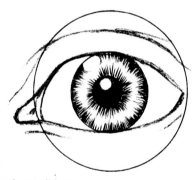

The Human Eye

The eye's almond shape is suggested by the muscles and skin around a large orb. This orb rests way back inside your head. You only see a small portion of the eyeball.

The Eyeball Is Huge

As you can see, the eye is a lot bigger than it seems! Yet the pupil and iris are much smaller than the whole of the orb. Remember that the skin surrounds the round surface. Keep your lines rounded.

What Eyelids Do

The eyelids shape and cradle the surface of the eye, giving the eye its characteristic almond look.

The shoujo manga eye is constructed just like a real eye, only it is much simpler to draw.

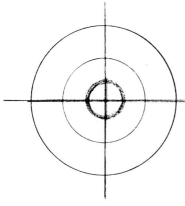

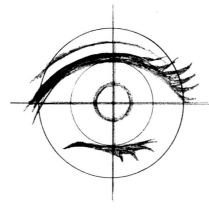

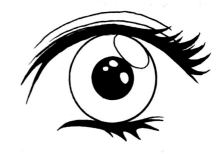

1 Draw three circles, as if you are drawing a bull's-eye target. The large circle is the orb of the eye; the smaller, the iris; and the smallest, the pupil.

2 Here's the big difference between the manga eye and the real eye. In the manga eye, the lids are almost never drawn to meet. Simply draw two sweeping sets of eyelashes. Make them as thick or thin as you like. Thinner eyelashes are usually drawn for men.

3 Ink in your drawing, add a couple of highlights, and you are finished. This is the simplest kind of manga eye to draw.

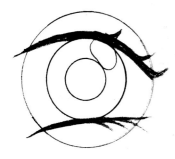

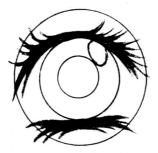

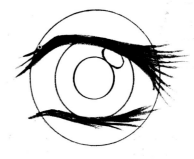

To get completely different looks, use the bull's-eye circle you drew as your basis for each kind of eye. Change the eyelid line. See how simple it is to draw very different types of eyes simply by moving around the lid.

EYE PROFILE

The profile of the eye is a bit trickier. It is easy to do but doesn't always follow the round shape of the eye. Let's take a look at the human eye again.

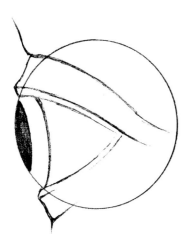

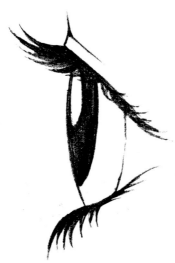

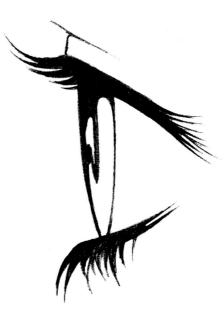

Eyes Protrude From Their Sockets
They look very round and you can tell how much of the eye is hidden from view as it sits back in the head and under the eyelids.

The Rare Manga Eye
This one is closest in form to the human eye and is constructed in the same way. Draw the curve of the surface flatter than a real eye. Manga eyes are so big and round that if you drew it from this angle the way a real eye is drawn, the eye would look like it was popping out of the socket.

Most Manga Eyes
A flatter curve and thinner iris is more common. Don't bother to draw the whole eye orb. From here on in, just draw a thin ellipse.

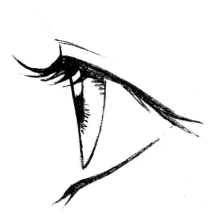

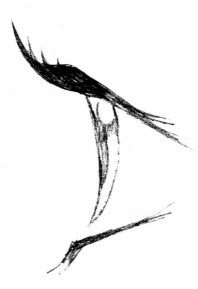

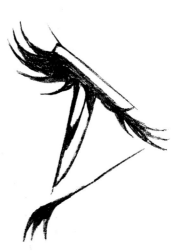

The Inward Curve
We know eyes don't really look like this one, but it's one of the unique qualities of some shoujo styles.

Exaggerated Inward Curve
An even more exaggerated inward curve is also common in manga. Draw the curve like the inner lens of eyeglasses.

Upper Portion Inward Curve
The construction of the real human eye and the manga eye have completely parted ways at this point, but this is easier to draw with a few strokes of the brush or pen.

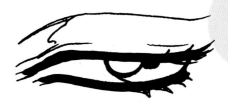

It's simple to draw the eye in expressive gestures using the same few strokes of the pencil you have already learned.

SNEAKY!

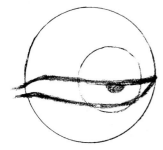

1 Looking off to the side with a sly expression! Draw the iris far off to the side of the eyeball and add two clean lines for the lids, covering most of the eye.

2 Ink in eyelashes and an eyelid to complete it. Add a touch of curved line at the corner of the lid to give the impression of roundness.

SURPRISE!

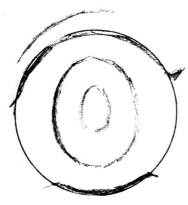

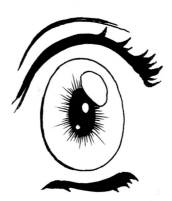

1 Some manga eyes do not have a round pupil. They sometimes have big, oval pupils like this one. Draw them freehand to give yourself practice drawing without a template. Your lines don't need to be perfect all the time. Draw the lines of the eyelids high above the pupil. Draw the crease of the upper eyelid as a simple line slightly above the orb.

2 Boing! Ink in your eyelashes and add a highlight to the iris. It's amazing how a few simple lines on paper can convey so much emotion. I'm surprised, too!

23

SMILEY

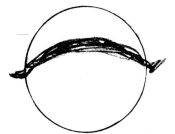

1 A happy, smiley eye is easiest of all. Draw just one big curved line over the upper middle portion of the orb.

2 Ink over that one line with thin lines and add little dashes for eyelashes. A simple line above all that is the eyelid.

NARROWED

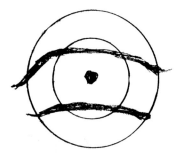

1 A narrowed eye can mean a lot of things. Is the sun too bright? Is someone concentrating very hard? Draw two simple curved lines over the iris.

2 Ink in the eyelashes and add a highlight. Even without a lot of detail, you can tell this is the eye of a man.

SQUINTY

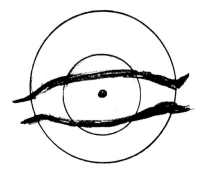 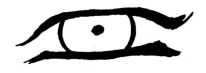

1 Squinty eye! Draw two narrow slits over the iris. Draw a couple of little upward marks at the ends to accent the eye's roundness.

2 Ink it in. Make the eye look really sinister by giving it a narrow pupil. This makes the eye look like it has laser intensity.

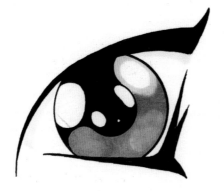

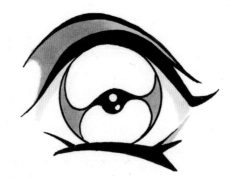

Create Pages and Pages of Eyes!

Beautiful manga eyes come in many shapes and colors. Experiment with different types. Give the eyes blue eyelashes or green lids. There is no one way to draw the shoujo eye. You can come up with your own unique styles.

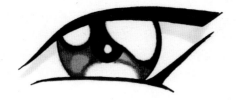

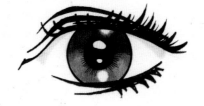

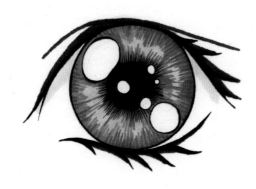

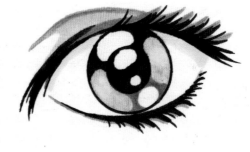

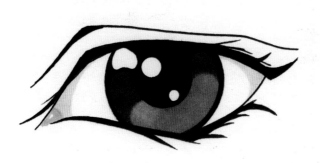

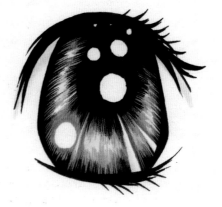

Simple Tricks for Special Eyes

I have a two-volume set of the history of shoujo manga that was published only in Japan. It has hundreds of illustrations of the work of all the classic artists.

Some of the styles were really funky. These particular eyes are rarely used now but were once very popular. They are so cool! They would make great alien eyes or eyes for faeries and elves. Try them out!

THE STARLIGHT EYE

The big difference here is that there is no pupil or iris or white of the eye.

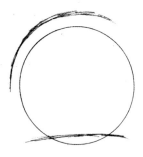 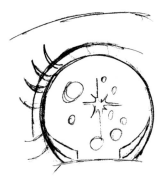 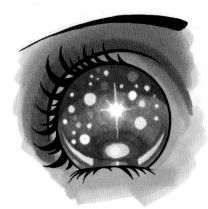

1 Draw a circle, just like you would for other eyes.

2 The whole top portion of the circle is your eyelid! Sketch eyelashes along that line. Sketch in circles and stars throughout the orb.

3 Trace your drawing in ink, or color it in. Colored, you can really see the incredible effect of this eye! Use three or more shades of blue for a dreamy effect. I added a computer starburst to my magic marker drawing for a special look, but you can use colored pencil, too. This is a great-looking eye!

THE STARBURST EYE

I love this eye. I know of only one manga artist who used it, but her work was incredibly popular in its day. Imagine this eye on a woodland elf! Use the same big circle base that you used for the Starlight Eye.

 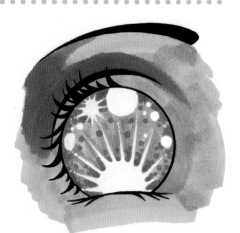

1 Make two circle sketches within the eye shape and draw radiating lines along the circles. Add lots of stars and highlights, too.

2 Color in your eye with moss green tones. Color other eyes in blues or golds for really interesting looks. This is definitely a shoujo style that needs to make a comeback. It's gorgeous!

OTHER EYE EFFECTS

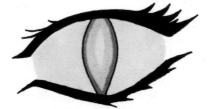

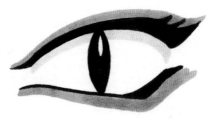

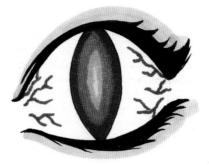

1 Another great look comes from this simple design. Draw a cat's eye slit instead of a round pupil.

2 Color the eye yellow with a touch of green on the slit of the pupil, and you have a great, supernatural look.

OR

2 Black in this eye leaving nothing but a dot of light in the pupil. Add a touch of gray under the eyelashes for depth. This is a great look for dashing demonic characters that are a little bit good and a lot bad!

OR

2 Draw red lines on the white of the eye for a bloodshot look. Use multiple shades of red and yellow in the pupil. Use this eye for vampires, demons and other scary characters!

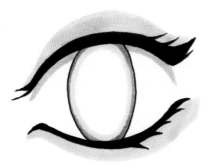

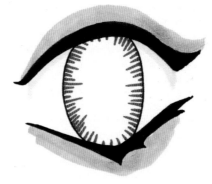

Blind or Entranced Eyes
For this kind of eye, use the oval shape you used on page 23. Add a touch of color only around the edge of the pupil and you can use this for blind characters. It is also great for indicating that your character is caught in a trancelike state.

Magic or Power Eyes
Draw tiny dashes of color along the pupil. This gives this eye the electric look of power.

THE JELLY BEAN EYE

Imay be the only person in the world who calls this sort of eye the Jelly Bean Eye, but it is the best description of the changing shape of this oval pupil often found in contemporary manga. From the front, the pupil is shaped like a simple oval, as we have seen.

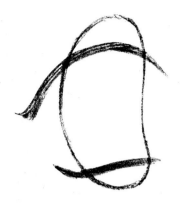

3/4-View Creates the Bean Shape
Turned to the side in ¾-view, the eye morphs.

Minus the Eyelid, the Pupil Looks Just Like a Jelly Bean
If you have any trouble drawing this eye shape, just get some jelly beans and keep them around your drawing board as a reminder.

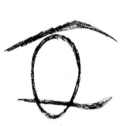

Exaggeration Stretches
Squash and stretch the pupil to exaggerate the facial expression. This is a common technique in both cartooning and animation.

This kind of eyeball can look like a perfect oval from certain angles.

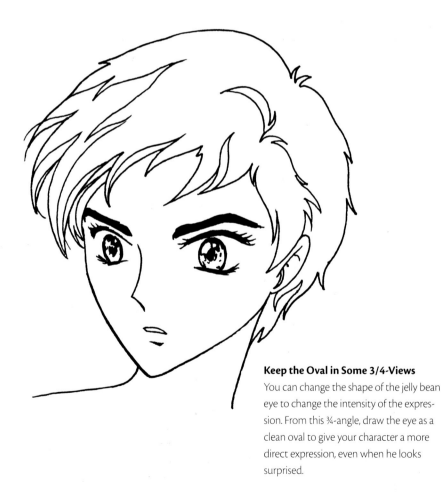

Keep the Oval in Some 3/4-Views
You can change the shape of the jelly bean eye to change the intensity of the expression. From this ¾-angle, draw the eye as a clean oval to give your character a more direct expression, even when he looks surprised.

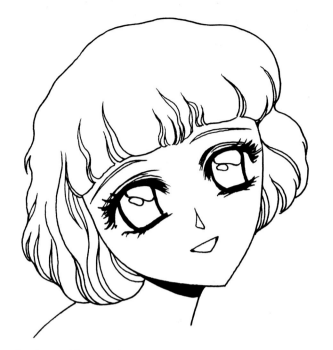

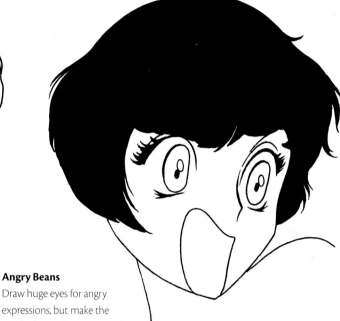

Sentimental Beans

A girl with a sentimental character might have enormous pupils like these. Draw the oval with a series of tiny lines instead of one sharp, clean line. This gives the eye a vibrating expression that swims with emotion.

Angry Beans

Draw huge eyes for angry expressions, but make the pupil a bit smaller. Draw small pupils to give the eye a pin-pointed, penetrating glare.

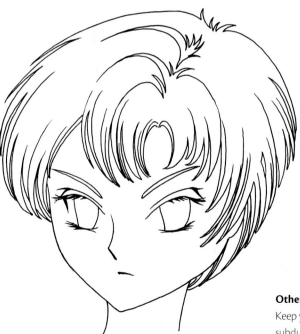

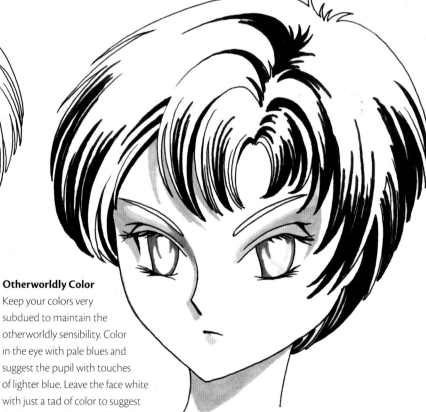

Otherworldly Beans

For an otherworldly quality, draw your black and white jelly bean eye as a simple, squashed oval with no detail at all. Is this person a psychic? Blind? In shock?

Otherworldly Color

Keep your colors very subdued to maintain the otherworldly sensibility. Color in the eye with pale blues and suggest the pupil with touches of lighter blue. Leave the face white with just a tad of color to suggest shadows. Use this kind of look for an alien or a mystic.

TEARS, CRY ME A RIVER

Shoujo manga's high drama will have you drawing oceans of tears. Most of us look awful when we cry, but in shoujo, crying almost always looks pretty.

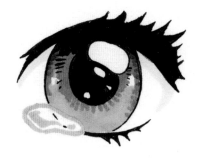

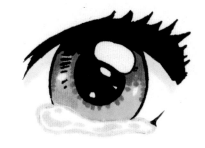

A Little Tear

On the inside of the eye lies a tiny tear duct. All tears start here. Draw the beginnings of a crying jag by putting a little bubble of water on the inner part of the lower eyelid. Allow the black pen marks to show through the tears to make them look transparent.

Getting Really Sad

Because the line of the lower lid slopes downward from the inner eye, draw the bubble of water as it leaks along that line. As the eye fills with water, add a little bit more shine to the iris.

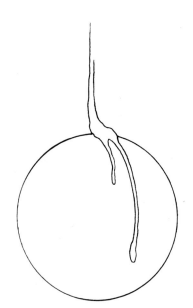

The Face Is a Curved Plane

The manga face doesn't have the same form as a normal human face, so it is easy to think of tears as water being poured over a ball.

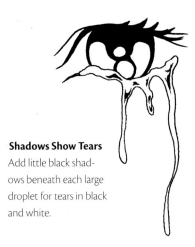

Shadows Show Tears

Add little black shadows beneath each large droplet for tears in black and white.

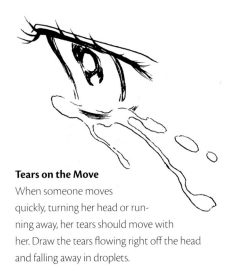

Tears on the Move

When someone moves quickly, turning her head or running away, her tears should move with her. Draw the tears flowing right off the head and falling away in droplets.

Tears Follow the Face's Curves

Especially in profile, make sure the tearflow follows the curve of the face. The face is not flat, and the tears should flow around the surface of the face.

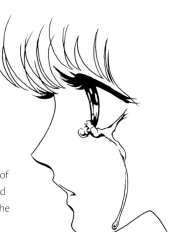

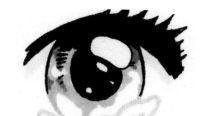

Beginning to Cry

Now we've got real waterworks! The tears are too heavy to stay on that little eyelid. Draw a line of water flowing down the cheek. Use white paint to add dashes of delicate lines of tears along the face and to add highlights.

Really Crying

Tears don't really look like this of course, but in manga, tears maintain their trailing shape all the way down the face. Add multiple rivulets of tears and add large, white highlights to the iris to give it a watery appearance.

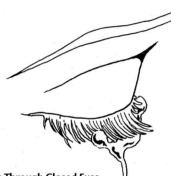

Tears Through Closed Eyes

Simply draw the silent drop of a tear slipping out from beneath the lashes. It should look like a little bubble that drags down into a drop.

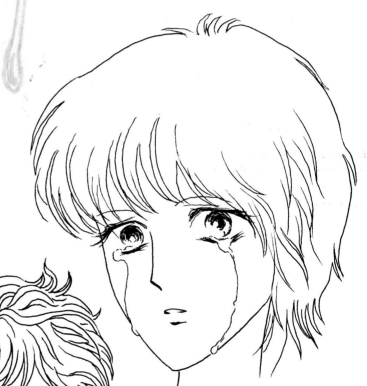

Draw Sobs as Rivers

There is more than one way to draw a face full of tears! Individual teardrops are almost never drawn. Make the face run with small rivers of lines. This guy is really sobbing! Note that the tears also follow the curve of the face.

3/4-View Tears

At this ¾-view, it is easy to see how the tears flow over the curve of the face. I drew these tears as delicate little trails with just the tiniest touch of water droplet at the end of the line of tears. Draw the eyeballs with short, delicate strokes to give the eye a liquid, delicate appearance.

31

 rofiles are really easy.

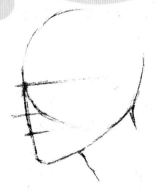

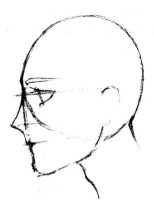

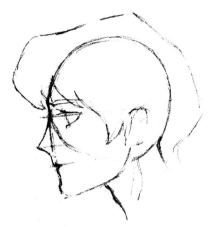

1 Draw a circle with the point of your triangle roughly even with the forward line of the circle. Add your guidelines.

2 Draw the nose and chin protruding a bit from the front of your triangle. Some artists give their faces very long noses and chins. Others keep them delicate the way we are drawing them here.

3 Block in the hair. Keep the hair big and fluffy. Make it much larger than the shape of the head.

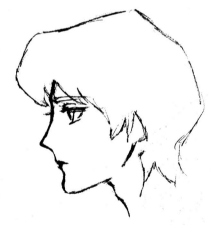

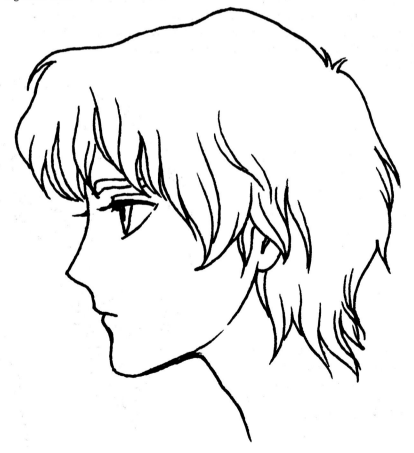

4 Clean up your guidelines. Isn't it amazing how close you are to a complete drawing when you get rid of your sketchy lines? This is one of the fun parts of drawing.

5 Add loose hairs to give your handsome hero a scruffy roughness. Keep ink lines clean and don't put too much detail on the face. Doing so makes the face look older.

This is the trickiest angle at which to draw the manga head. A lot of artists avoid it because the manga head isn't constructed like a normal human head, and if you are not careful, you can make the chin look lumpy and awkward. I spent a lot of time looking for artists who draw this shot well. In one case, I went through hundreds of pages of the work of one artist without seeing one example of this angle in his art. Some artists do use it. They solve the problem the same way you will here.

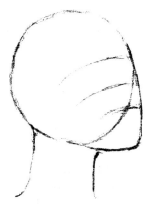

1 When attaching the chin triangle to the head circle, always lead with your chin! The point of the chin should be on a horizontal line with the bottom of the circle. Attach the triangle off-center in a clean, curved line along the curve of the head circle.

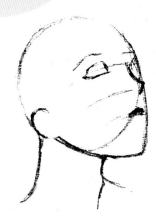

2 See how heavy the jaw and chin will look if you're not careful! Draw the jaw line for now to help you properly place your features. Don't worry! You will get rid of that heavy jaw soon!

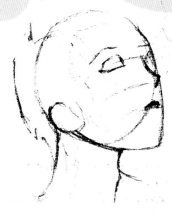

3 Block in the hair and tighten up your drawing on the features.

4 Now we are going to solve that heavy chin problem the way most manga artists do. Simply erase the line of the jaw. It's amazing how this makes the face look more delicate!

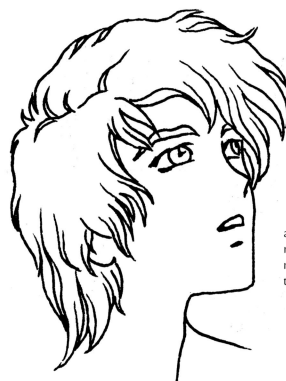

5 Clean ink lines finish off the picture. Make sure the mouth sits a bit inside the line of the nose. Other styles let the mouth jut outward but not this one.

3/4-View Down

This ¾-view down shot looks tricky, but following these steps makes it easy to do. No matter which way you draw the head, as long as you keep that circle/triangle combination and place the tip of the triangle in the direction you want the head to face, you can't go wrong.

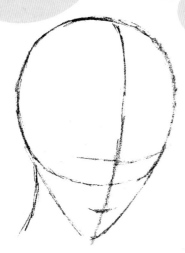

1 Draw your eye, nose and mouth guidelines.

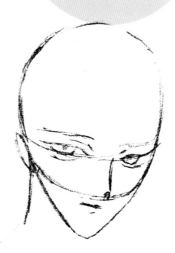

2 Sketch in the features. It's easy when you have your guidelines in place. You don't have to be neat or tidy. Keep your sketches loose and your drawing light. It's easier to erase light pencil marks.

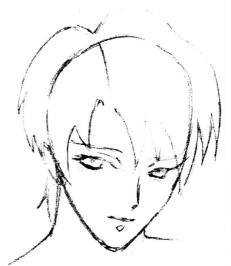

3 Erase your guidelines and see how sharp your drawing is already! Let the features flow around the head and keep a gentle touch on your lines.

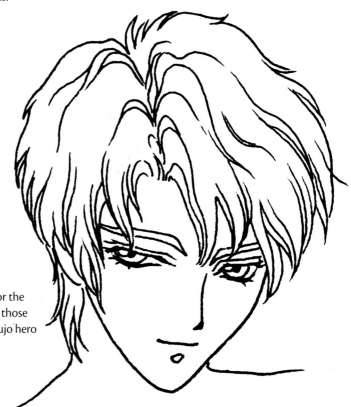

4 Add clean, graceful lines for the hair and be generous with those eyelashes! A beautiful shoujo hero needs his gorgeous eyes!

 ow try it straight!

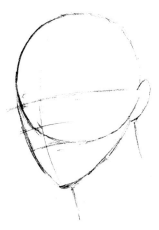

1 Face construction doesn't change much no matter which way the head is turned. From this angle, the jaw triangle is a bit fuller than the ¾-view down shot.

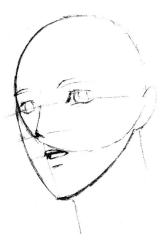

2 Add the features over your guidelines. Let them curve around the head along the shape of your lines.

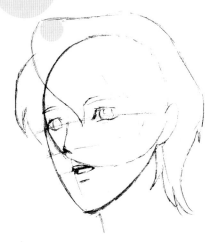

3 Block in the hair with simple strokes. Don't worry about a lot of detail at this point. Structure is more important right now.

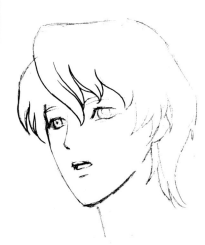

4 Remove your guidelines. You are almost finished! Clean up your drawing to make it easier to ink.

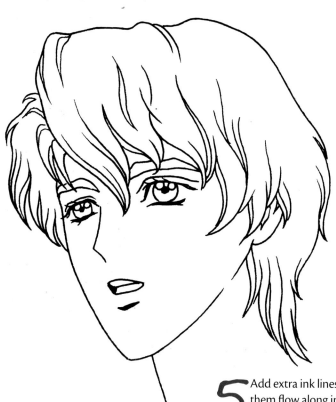

5 Add extra ink lines to the hair. Let them flow along in delicate strokes with the main hairstyle's shape. This gives the hair a sense of mass without being too ornate.

The Shoujo Boy

The dark-haired, dark-eyed boy with the direct gaze and the tortured teen angst storyline is a staple of shoujo manga. He is pretty enough to be attractive but has masculine style, so there is no mistaking this cute guy for a girl!

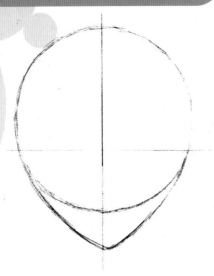

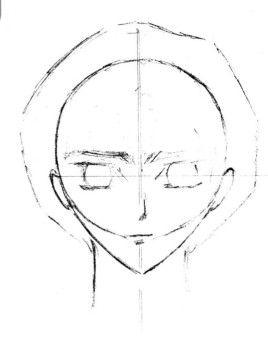

1 Draw the circle with a shorter triangle.

2 Block in the lines for the places you want to set the features. There is no difference here between the boy and the girl, except the boy has narrower eyes.

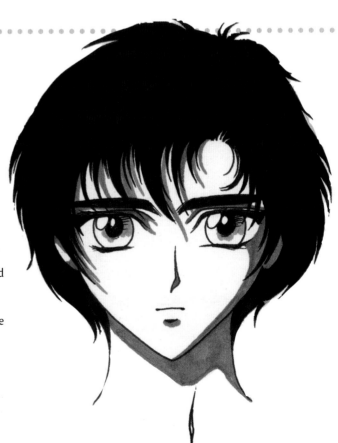

5 Draw dark brown and gray shadows around the form of the face, under the hair tendrils, and around the eyes. At this stage, this looks almost like an anime cel. Add some gray to the shadows around the eyeball. This keeps the eyeball from looking too flat.

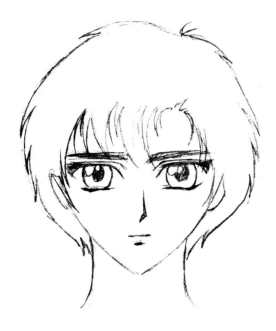

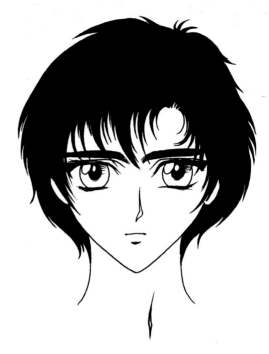

3 Remove the guidelines and clean up. To make his face look more masculine, give him a narrower mouth. This suggests a determined character. Draw his nose a little longer and less rounded. His eyes are still very big, but add heavy eyebrows to make him stern. He has big, beautiful eyelashes, but make them more of a solid block around the eyes. Add a few individual lashes, but stay away from big, fluttery lashes.

4 Ink his hair flat black, with no highlights at all. This is definitely the head of a shoujo boy—it's the exact same shape as the head of the shoujo girl. The difference is in the details!

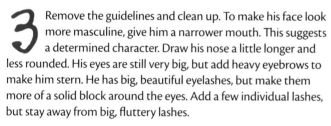

6 This fellow does not get rosy cheeks. He's too tough for that! Color over the shadows of his face with a flat flesh tone. Go over the face and hair a couple of times with your colors to get the smooth tone you want. Use several different shades of brown on the eyes and add a couple of small highlights. Don't overdo it with pretty touches on this kind of face. You will make him look girlish. However, a highlight or two on the lips makes him look kissable, and that's OK!

Girl, Profile

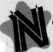 ow let's get a look at the girls of shoujo! Once again, we'll start with the easiest, the profile view.

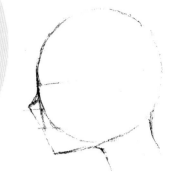

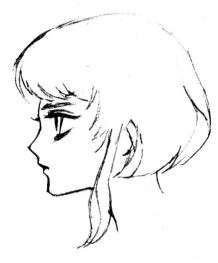

MORE HEADS and FACES?!

Yep, we're spending a lot of time learning to draw the shoujo head. It's the most important feature of shoujo. You can have a great deal of variety in body type, but shoujo fans want faces to look right.

1 The circle with a small triangle at the bottom is your base for the profile. Compare it to the boy's profile you have already drawn. This shorter chin makes this face much younger-looking.

2 Draw the eye profile into the head with a slight tilt. Some artists make the eye tilt inward, some outward. This style usually tilts in, almost as if the eyeball is falling a bit into the head.

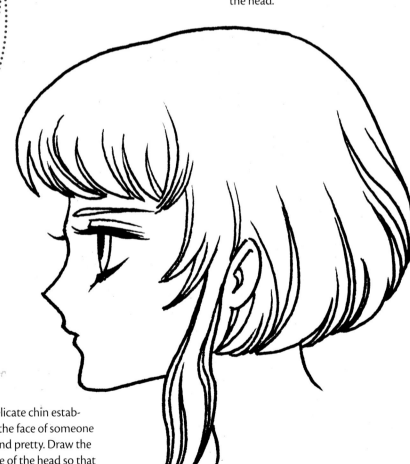

3 The short, delicate chin establishes this as the face of someone very young and pretty. Draw the eyelash on the far side of the head so that it can be seen from this angle. We know that doesn't happen in real life, but this is manga!

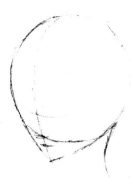

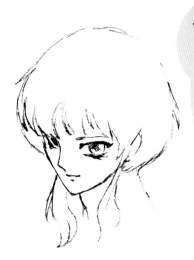

When drawing from this angle, it's tempting to lengthen the chin too much.

1 As small as the chin looks from the front, draw it even smaller from this angle and remember to let your guidelines curve around the head. The face isn't flat, even if it is just lines on paper.

2 Follow the shape of the head when drawing hair. Let the hair move a bit. If it is drawn too perfectly, it looks stiff and unconvincing.

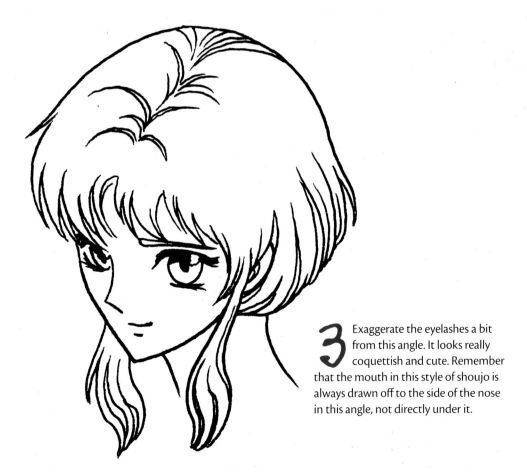

3 Exaggerate the eyelashes a bit from this angle. It looks really coquettish and cute. Remember that the mouth in this style of shoujo is always drawn off to the side of the nose in this angle, not directly under it.

Girls and guys in shoujo manga often look a lot alike. Many manga feature boy characters that are so pretty we have to be told we are looking at a boy! There usually isn't any significant difference in the way the heads are constructed. Girls may have large eyes and big eyelashes, but guys can, too.

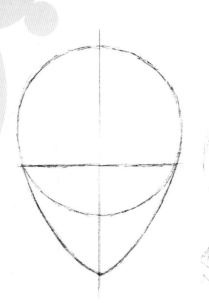

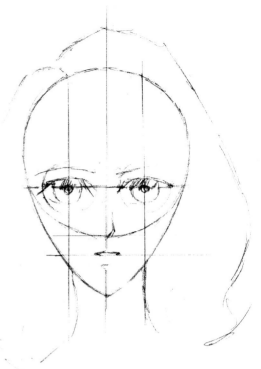

1 Start off with a fairly pronounced circle and triangle. This is the kind of face shape you might use on an older teen or adult woman character. A long face shape for this kind of female character looks more mature.

2 Block in the features and hair. You might want to make your female character's eyes a bit larger than the boy's eyes, and add longer hair to make her look more feminine.

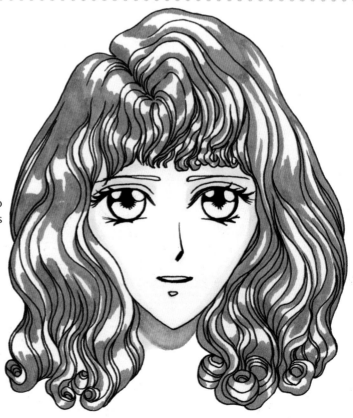

5 Manga characters often have wildly colored hair. This serene, pretty lady could be a mermaid, so make her hair blue. Draw long dark strokes for the shadow areas of her hair. Leave the areas you want to appear brighter and shinier open. Use dark colors to indicate shadows on the face.

3 Erase your guidelines and tighten up your drawing. You want to keep your drawing neat at this stage because you want to minimize the chance of mistakes when you go to ink it. Draw her mouth open just a little bit. She has such a direct gaze. Perhaps she is trying to speak to you.

4 Getting smooth, flowing lines of hair takes some practice. Smooth parallel lines show the flow of the hair. You can leave the little shadow under the lip as an open oval, or you can black it in.

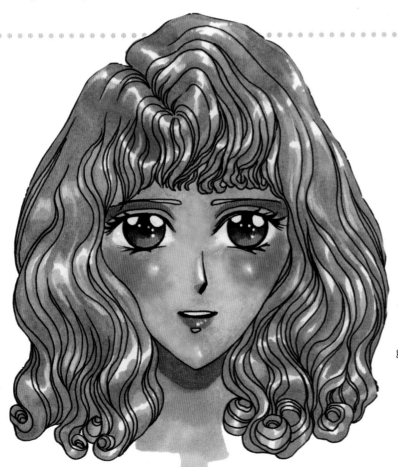

6 Using a lighter aqua blue, color in large portions of the hair, again leaving white highlights. You can also use a dab of white paint for highlights. Go over the face several times with your markers to smooth out the tones. Experiment with colors on the face. Small touches of blue or gray make interesting shadow tones. Add extra highlights to the eyes and lips with white paint. Don't use such dark colors that you can't see the lines of your drawing underneath. The beauty of manga is in the graceful line work.

Now use another head shape to draw a shoujo girl. Younger characters generally have shorter or more rounded triangles for their chins.

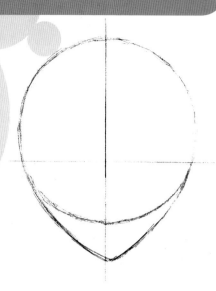

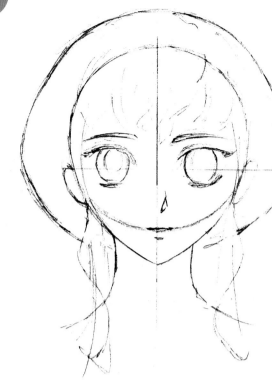

1 Draw the circle with a shorter triangle.

2 Add the guidelines and block in the hair. Make the eyes really big. Give her one of those huge, cute, fluffy hairdos! Add tendrils of hair hanging down about the ears. Remember to keep your sketch light and simple at this stage.

5 Go with another wild manga color for hair: in this case, pink. Draw in the dark-colored areas of the hair and leave large areas blank for highlights. A cool gray is the perfect tone for shadows on the face. Draw in the shadow under the chin, add shadows below each tendril of hair and around the edge of the face and eyes.

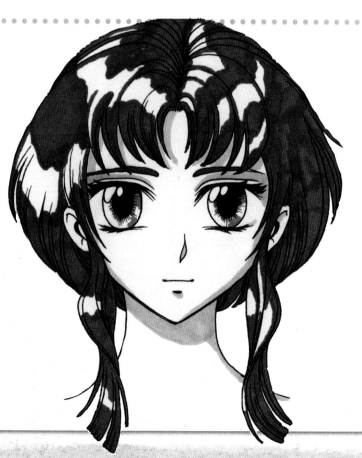

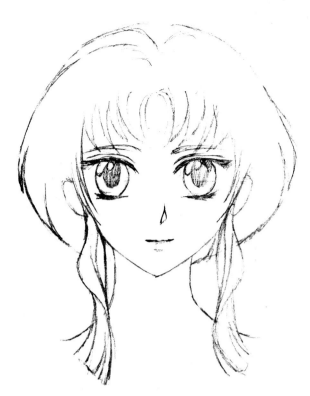

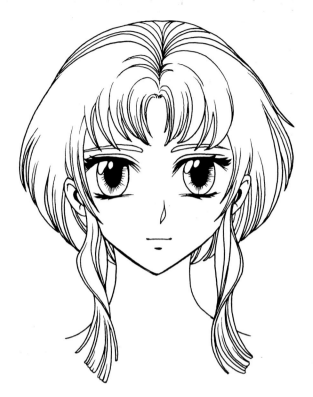

3 Clean up your drawing. Erase all lines you won't use in the final work. My drawings look darker here because we have enhanced them with a computer so they will show up when printed. Don't make your drawings this dark. Use a light hand when drawing at these early stages.

4 Inking isn't just about tracing. A lot of grace and style goes into the pen lines. Keep your line delicate. Add tiny lines radiating from the pupil to make them look even prettier. Most manga are published in black and white. It is crucial to learn to draw in ink.

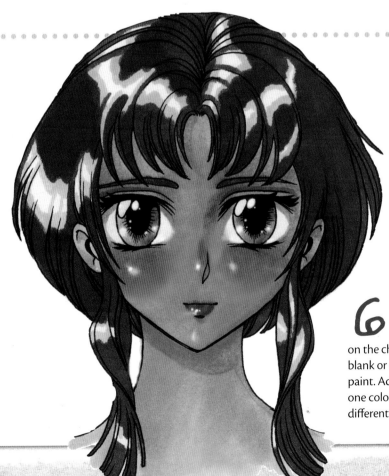

6 Use a slightly pinker skin tone to compliment the hair. Achieving smooth pink cheeks is tricky. I used the computer to smooth mine out! Create highlights on the cheeks, nose and chin either by leaving those areas blank or drawing them in with a white colored pencil or white paint. Add a few more highlights to the eyes. Use more than one color for eyes to make them really luminous. I used three different shades of green here!

The Romantic Hero

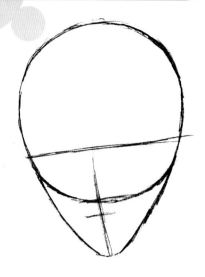

The romantic lead type is a very popular look, so let's take a little extra time studying him. I bet you love drawing cute guys, so this is going to be no problem! He looks a little different than the shoujo boy you drew on pages 36 and 37, but he is just as easy to draw.

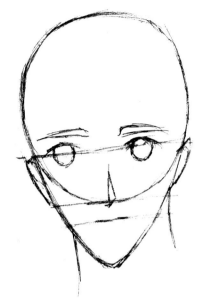

1 Simple and easy, draw a circle and a triangle to start. Draw these free-hand. It's not necessary to be perfect at this stage, these are just guidelines. Sketch in your center line and lines for mouth and nose.

2 Roughly sketch in the features: eyes about halfway down the head, nose about half below that, mouth about half below that. The shapes are quite simple. The eye sketch is just a circle with a line over it.

GIRL TO GRRRL TIP

The larger your drawing, the harder it is to create smooth areas of color. Good-quality marker sets come with a colorless blender marker that helps to smooth out those blotchy tones. However, be careful with it! It can make your colors bleed into places you don't want them to go! Airbrush markers are also handy, but if you can't get them, make your original drawings smaller. Fewer "streak" effects will mar your images.

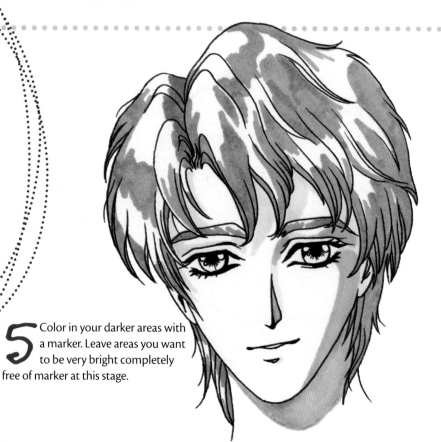

5 Color in your darker areas with a marker. Leave areas you want to be very bright completely free of marker at this stage.

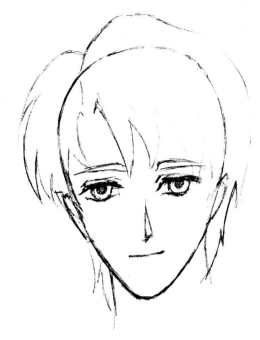

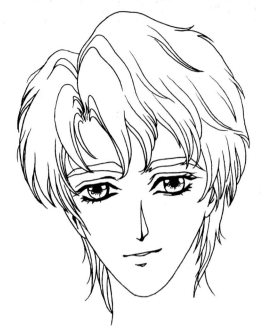

3 Now you're getting somewhere! Erase your guidelines, block in the shape of the hair and add more detail in the eyes. Erase any extra lines. You'll be inking your drawing after this, so it's important to erase extra lines. You don't want to get confused and ink some line in you didn't want to keep!

4 You can ink with a black marker using a very delicate point. Some artists even use a brush or a crow-quill (G-Pen). At this point, drawing is all about adding style and grace. Add little details and flourishes. This kind of line work can be learned only one way: practice! Get the look of hair by blocking in the basic shapes, then adding small sections of hair detail with fine lines running parallel to your main hair shapes. (Practice on a separate sheet of paper before you place them on the drawing.)

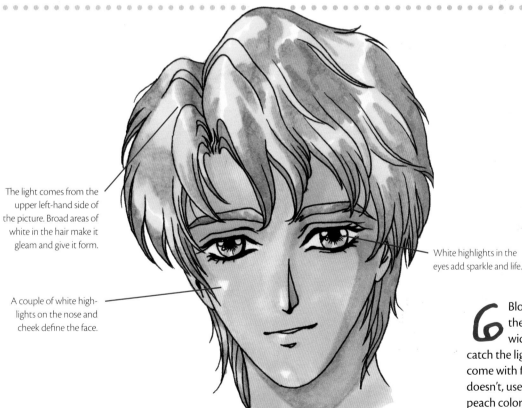

The light comes from the upper left-hand side of the picture. Broad areas of white in the hair make it gleam and give it form.

A couple of white highlights on the nose and cheek define the face.

White highlights in the eyes add sparkle and life.

6 Block in broad areas of color with the wide tip of the marker. Leave wide areas of the hair open to catch the light. Most quality marker sets come with flesh tone markers. If yours doesn't, use pale pinks, powder pinks or peach colors. For darker skin tones use sepia, umber and other pale browns.

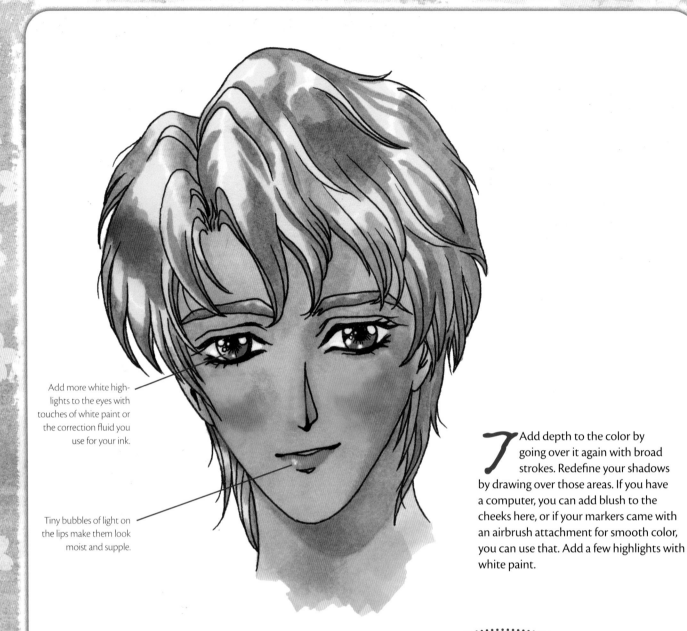

Add more white high-lights to the eyes with touches of white paint or the correction fluid you use for your ink.

Tiny bubbles of light on the lips make them look moist and supple.

7 Add depth to the color by going over it again with broad strokes. Redefine your shadows by drawing over those areas. If you have a computer, you can add blush to the cheeks here, or if your markers came with an airbrush attachment for smooth color, you can use that. Add a few highlights with white paint.

KEEP IT SIMPLE

Manga artists have to work very quickly, so they develop art styles that can be used to create works in very short periods of time. Some artists have to create several pages a day. They have assistants to help them, but these assistants have to be able to work in the master manga artist's style. Styles are usually kept simple and easy to copy so that artists can create works fast and train their assistants in their style.

DRAWING THE FIGURE

The human figure is a complex subject, and there are many books that can give you a complete overview of academic figure drawing. Drawing in a shoujo style is a bit different from classical figure study. While you will need to study classical figure drawing to *master* shoujo style figure drawing, you can get the basic techniques to achieve the shoujo look right here.

Shoujo figures are usually supermodel lean. They have a special, elegant grace and are easy to draw because the emphasis is on the lean line of the figure and not on com-plex musculature. Also the lean shoujo figure looks great in clothes! The fabric drapes over the form as it drapes over a coat hanger, with an effortless drop.

There are two basic types of form for drawing the shoujo figure. Some shoujo styles are best drawn with the manne-quin form (e.g., aesthetic, illustrative and retro—you'll learn about those later), but other shoujo styles look better using the stick figure construction. We're going to go over both construction forms right now.

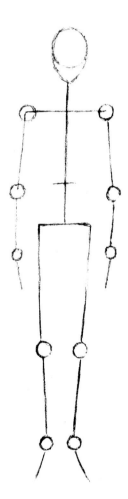

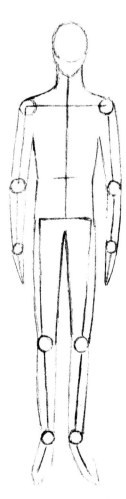

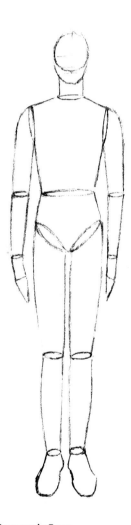

Stick Figure Form for Shoujo

The stick figure is best used for the waifish fashion model figures of modern and contemporary style shoujo. It is much easier to draw than the mannequin form.

Connect the Dots

Rounding off the stick figure form is a lot like playing connect-the-dots! Just let your pencil roll over the circles that represent joints. The drawback to this style is that it is less precise than the mannequin form. Mistakes are easy to make because the drawings are very gestural and loose. However, it is easy to make corrections and very fast to draw this way.

Mannequin Form

This is the form used in classical drawing (see page 12). This is best used for manga styles that have some bulk. It will give you the most proper alignment of muscles and bones, but it takes some time to master.

STICK VERSUS MANNEQUIN

Let's take a close look at the stick figure construction style versus the mannequin construction style. You will be using both in this book.

The full body mannequin form makes the form appear solid from the get go. Drawing lines all the way through and around the form is called *drawing through*. Drawing through gives the impression of 3-dimensional form in 2-dimensional space. This way, you can understand how all parts of the body relate to one another, even the parts you can't see, and how clothes flow over the body.

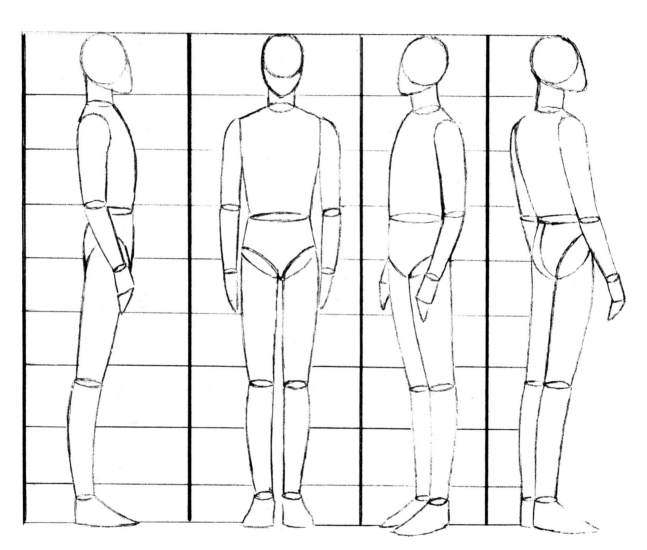

The Typical 8½ Head Figure Profile
The horizontal lines indicate the line up of the heads. Pay careful attention to where parts of the body correspond to these lines. No matter which way the figure turns, the lines meet the body in exactly the same places.

Body Part Placement Remains Consistent Regardless of Viewpoint
With every turn of the form, the placement of body parts remains consistent. For example, the elbow falls at the waist and the wrists rest at the hip.

...And Size
Even though this body is a full 1 to 1½ head larger than a normal person, the placement of body parts on the form is consistent. If you decide to make your figure 4, 10 or even 12 heads high, just make sure you create a turnaround design like this for your figure so their proportions remain consistent from every angle.

The stick figure construction accomplishes the same purpose, but the figures seem a little flatter and lankier.

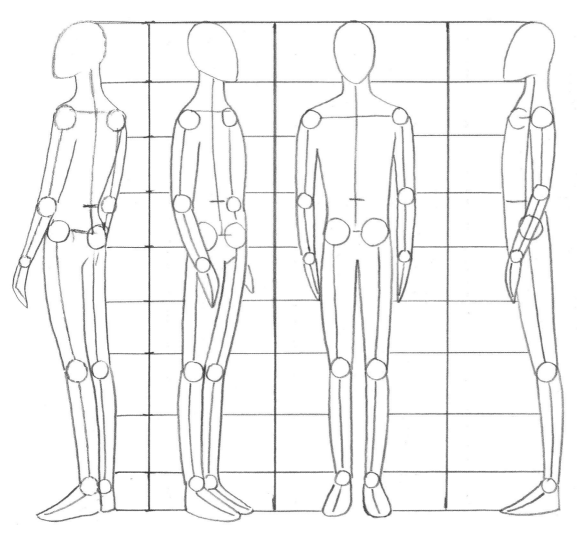

Stick Figures Are Less Realistic, but More Manga

The main difference between the two approaches to figure drawing is style. Using the circles as joints and playing connect-the-dots with the joints results in a thinner, less realistic figure, but one that is closer to many manga drawing styles.

Be Wary!

Because you are not drawing through your form as thoroughly as you are with the mannequin, you are more likely to make mistakes. The stick figure approximates the basic shape of the skeleton, but does not represent human musculature quite as well, so it's easy to create imperfections in the underlying body shape. But, no worries!

You Have Erasers for a Reason

If you make a mistake, just fix it! Don't be afraid to doodle your heart out and make all the mistakes you want. Drawing is an endless learning experience. Learn to draw using both of these techniques. The skills will serve you no matter what you draw.

BODY SKETCHES

I've often heard manga fans say they don't need to learn to draw American style because manga is different, and American style drawing skills aren't necessary. This is simply not true. Almost all manga forms use the same rules that western style academic artists use. The difference is in the details. Anything you learn from western academic drawing techniques is not only useful in drawing manga, but in some manga styles, these skills are essential.

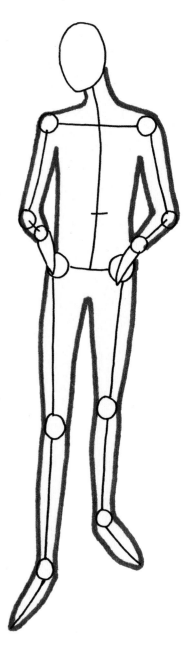

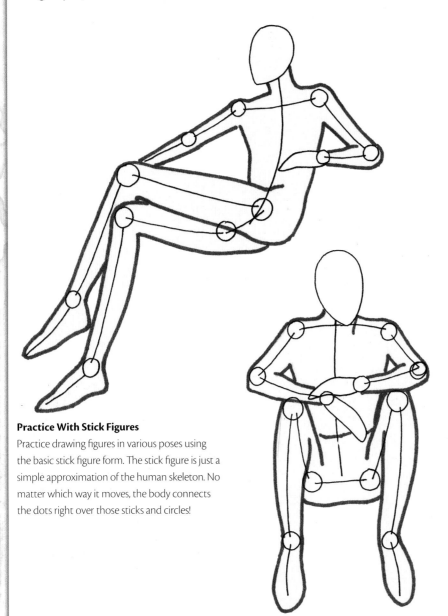

Practice With Stick Figures

Practice drawing figures in various poses using the basic stick figure form. The stick figure is just a simple approximation of the human skeleton. No matter which way it moves, the body connects the dots right over those sticks and circles!

Draw Friends or Work From Photos

The biggest difference between some kinds of manga art isn't in how the figure is drawn but in how the head and costume details are drawn.

Manga Is Based on Realism

While some manga use very exaggerated poses and body types, almost all of the shoujo looks are based on this simple and basic drawing style. Modern manga, especially, rely on natural, realistic poses like this one.

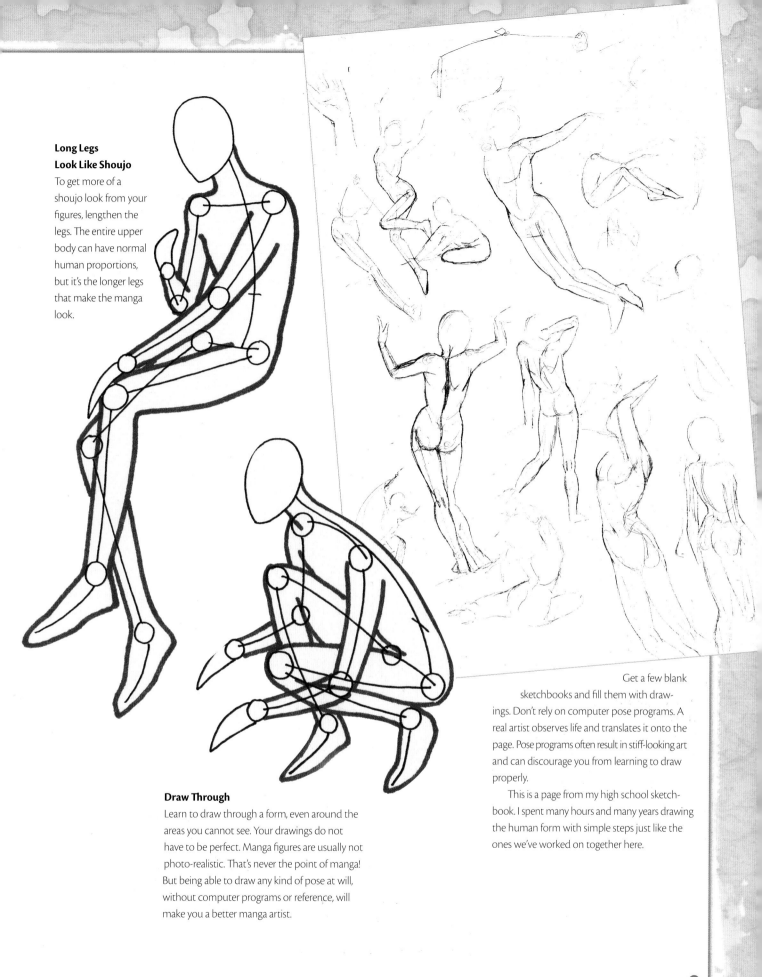

Long Legs
Look Like Shoujo
To get more of a shoujo look from your figures, lengthen the legs. The entire upper body can have normal human proportions, but it's the longer legs that make the manga look.

Draw Through
Learn to draw through a form, even around the areas you cannot see. Your drawings do not have to be perfect. Manga figures are usually not photo-realistic. That's never the point of manga! But being able to draw any kind of pose at will, without computer programs or reference, will make you a better manga artist.

Get a few blank sketchbooks and fill them with drawings. Don't rely on computer pose programs. A real artist observes life and translates it onto the page. Pose programs often result in stiff-looking art and can discourage you from learning to draw properly.

This is a page from my high school sketchbook. I spent many hours and many years drawing the human form with simple steps just like the ones we've worked on together here.

Male

Y̶ou know all the basics. So let's dive right in and draw a shoujo boy figure. We've spent a lot of time on the contemporary style, so let's try something a little different. The modern style is easy to draw using the stick figure technique. These fashion-thin figures are long and graceful and look great drawn with simple, clean lines.

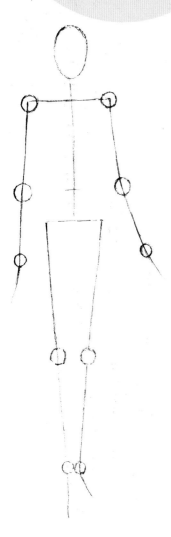

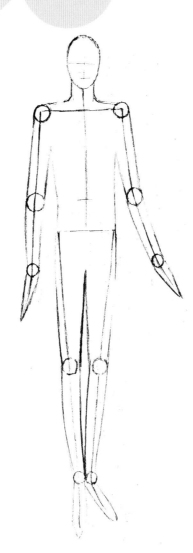

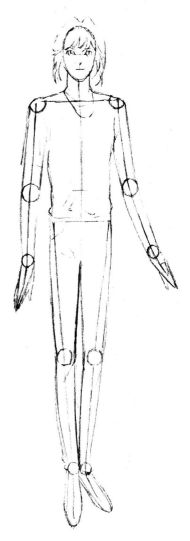

1 Draw your basic stick figure form in whatever pose you wish. Draw circles to indicate joints.

2 Roll your pencil right over those circles. Skim the form lightly.

3 Flesh out the form a bit. I think his shoulders are a bit too high, but here's the beauty of the stick figure drawing style—it's easy to correct. A couple of flicks of the eraser, and his shoulders sit better. Removing just a small amount of the shoulder joint between steps 2 and 3 corrected the problem. Like I said, your eraser is your friend!

MODERN STYLE SHOUJO

This figure and the female figure on pages 54 and 55 are both done in the modern style, typically used in teen and mature dramas. Notice how these characters feature less facial and figure exaggeration and more naturalistic poses, and their hair and clothes do not flow in wild lines. Turn to chapter 3 for more detailed tips for drawing this style.

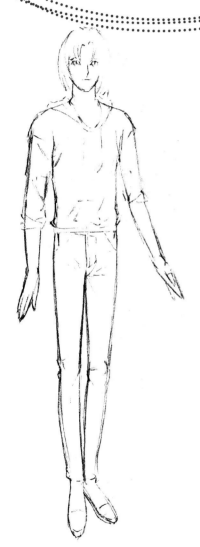

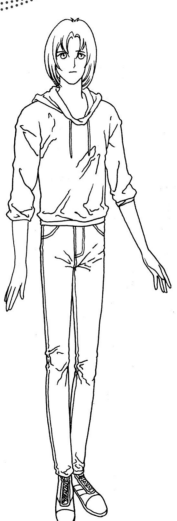

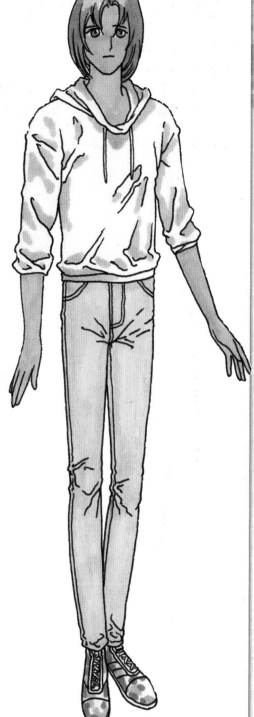

4 Draw clothes and hair to sit on top of the body. Always draw the form of the body before adding clothes and hair. Draw the hair in a mass on top of the head. Block out its simple shape. Draw the clothes to move over and around the body. Wrinkles follow the shape of the body. (See pages 65–69 for more clothing tips.)

5 Any kind of ink tool is OK, but I always use my Deleter marker for these delicate lines. Keep the lines simple, and don't worry about making little imperfect lines on clothes. Those imperfections give the clothes a slight wrinkle, which is more realistic. Keep the large mass of the hair fairly blank, leaving most of the detailed line work to the part and ends of the hair. Add final touches to the folds and hair details.

6 Add colors with markers. For a light sweater, color in only the shadows. Place most shadows in a little colored "nest" in the crooks of the wrinkle lines. Leave most of the area of the jeans and body as one, flat color. Simple colors look nice on this kind of drawing.

Female

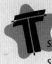 here's very little difference between the male and female shoujo construction. Shoujo girls are often very thin, so slim hips and a small bosom are common.

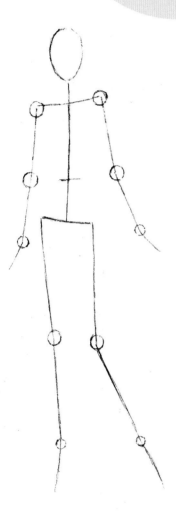

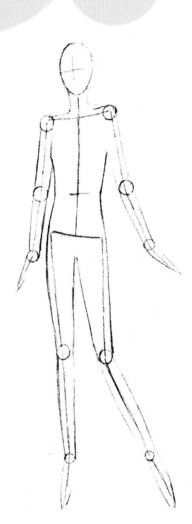

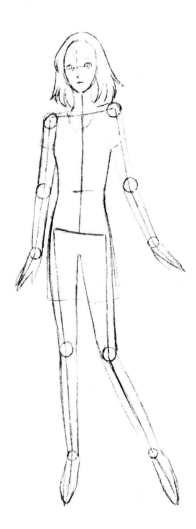

1 The shoujo girl will have smaller shoulders than the shoujo boy. The stick figure works here, too.

2 Draw the form over your circle joints. The girl's waist will be slightly smaller and her hips slightly larger than the male's, but not by much.

3 Lightly sketch in the body details. Give the girl graceful, tapered legs. Always indicate form before beginning to add clothing.

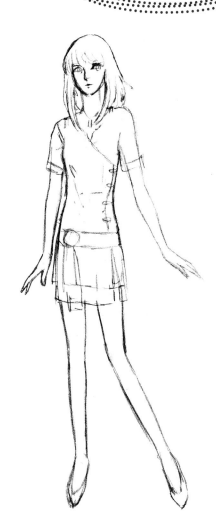

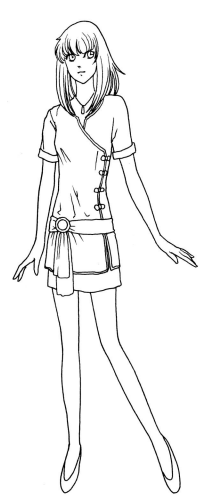

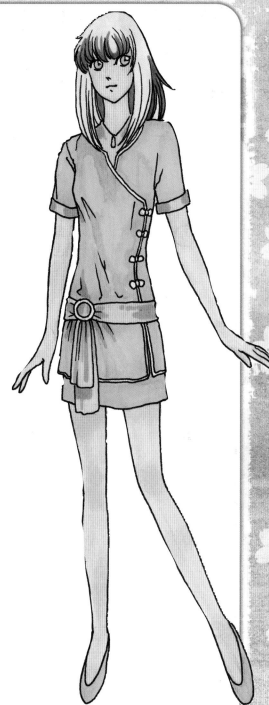

4 Add feminine clothes and a girlish hairstyle. This makes the biggest difference! A winsome figure in stylish clothes is the most common girl type in shoujo for teen readers. Draw the clothes and hair to fit the body. Give this girl a Chinese-inspired costume with modern details; a Mandarin collar and sash adds emphasis to the smooth curve of her hips. Draw the waist with a very slight inward curve and sketch in lines to show the tension of the fabric at the sash. Give her hair a full, but simple shape.

5 Finish your drawing with simple, elegant ink lines using a fine point marker or other inking tool. Just as you did with the male on page 53, leave the large mass of hair at the crown of the head fairly simple, adding most details at the hair tips and ends with parallel lines of varying widths. Keep the costume simple, adding most lines only at tension points such as where her sash rests. Draw the line of the buttons so that it follows the in and out curve of her figure.

6 Spring green is a current, popular color. Add a touch of gold to the sash with a dark yellow and a light yellow.

Female Figure

The stick figure drawing technique works for many kinds of shoujo art. The contemporary style shown here uses the exact same techniques but gets you very different results! The framework of the drawing styles usually don't vary much. The difference is in the details. Except for the construction of the head and costumes, the drawing tips for this contemporary look are similar to the drawing tips for the modern shoujo look. The contemporary style has more exaggerated line work, sharper angles and wilder hair! The figures are more lively than in the modern look and have a lot of energy.

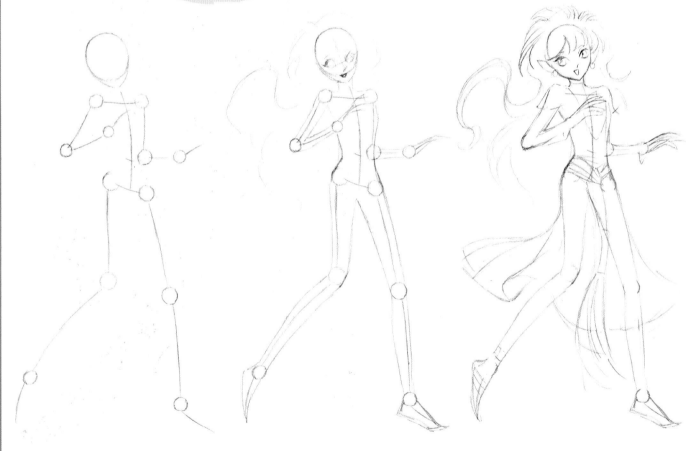

1 Draw her in a skipping pose. Be sure to draw through the areas of the body you can't see in the finished drawing. Portions of her legs and arms will overlap, but sketch them in anyway. This gives you a better idea of how the areas of the body and clothes relate to one another.

2 Connect the dots to round out your form. Draw slightly curved lines to indicate the slope of the legs and arms. Even though she is very thin, you want her to have a figure that has some mass. Keep the figure supple. Give her large eyes for a more feminine appearance. Big, pointed ears add to the magical look.

3 Add free-flowing lines for her clothes. The clothes wrap around her body. The body fits the clothes, the clothes don't fit the body. So, let the clothes respond to the shape of her form.

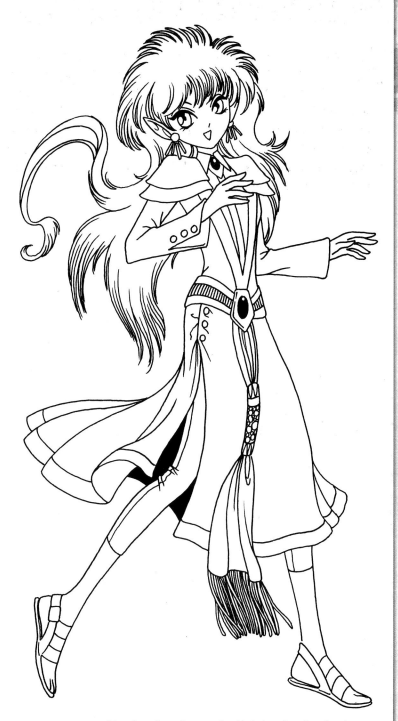

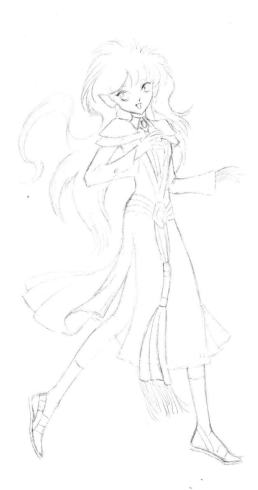

4 Erase your major guidelines and clean up your drawing. You want a tidy pencil drawing before you ink. Sketch in costume details along her sash and shoulders. Keep her feet arched and delicate. This gives her figure a light, dancing look.

5 Use clean lines for your final ink drawing. Render the hairstyle shape with graceful, curving strokes. A series of these strokes in close parallel gives the hair a sense of motion. It takes some practice to do, but it looks very pretty! Add costume details at this stage, such as the tassels on the sash. This sort of detail is very difficult to do in pencil, but easy to do in ink, so save it for last.

Using References

A manga artist has to be able to draw almost anything, so it is important to have extensive reference files on hand. Using reference doesn't mean copying what you see as if you are a human photocopy machine. Sometimes a finished drawing will look almost nothing like what you started out with. Of course, you should never copy or trace art or photos that do not belong to you for work that you intend to publish. Studying, copying or tracing others' photos and art is fine for practice, though. For absolutely original art, take your own photos and create your own references.

I keep files on almost every subject. I can do entire projects without ever looking at a file, while others require extensive research. I hate to break it to you, but I study more now as a professional artist than I ever did as a student. Get used to lots of reading and research. It's OK, though. It's fun stuff!

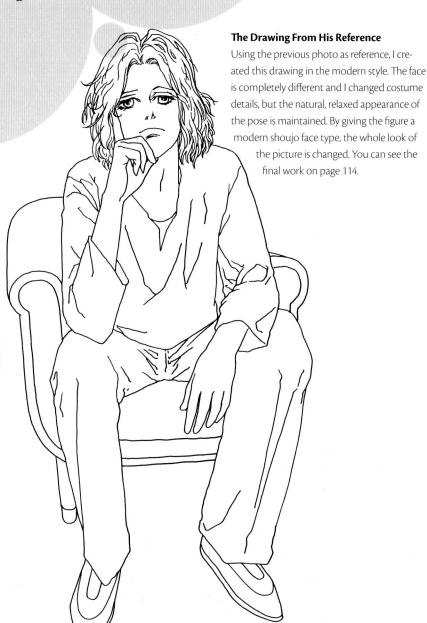

The Drawing From His Reference
Using the previous photo as reference, I created this drawing in the modern style. The face is completely different and I changed costume details, but the natural, relaxed appearance of the pose is maintained. By giving the figure a modern shoujo face type, the whole look of the picture is changed. You can see the final work on page 114.

Meet My Friend Jarl Benzon
Jarl is my model. He has posed for me many times. He has the perfect look for manga because he is very tall and very thin. He also has the perfect look for elves! He played a number of small roles as an extra in *The Lord of the Rings* films. He was also Orlando Bloom's body double. That's Jarl you see dressed as Legolas in many of those long shots of the Fellowship running around Middle Earth. An artist, Jarl also has his own website at www.jarlbenzonofficialfanclub.com.

Same Model, New Picture

Jarl is at the ready with a big sword. I think this picture makes a good pose for a an elf, only in the contemporary manga style! With the same model, we will create a completely different kind of picture.

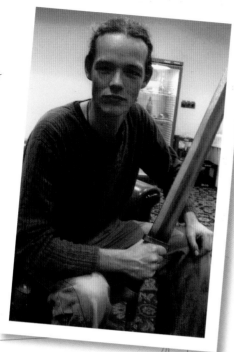

Start with the rough sketch of the picture using the stick figure technique.

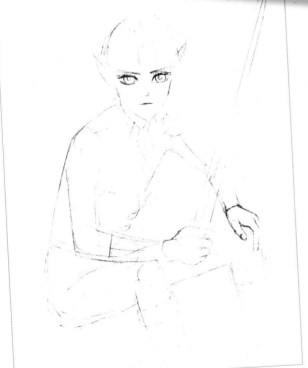

2 Round out the figure and tighten up the face. It's a good idea to tighten up your faces early in the drawing. It gives the picture a living presence. Block in the costume design. Consider details of your character's personality, environment and ethnic background when designing clothes. A forest elf should have clothes that fit close to the body and that don't interfere with his movement. Since Elves are a Northern European type of character, give this elf boots that look like they could have come from old Finland, a leather jacket that fits tightly and armlets (called *vambraces*) to protect his wrists.

3 Erase your guidelines. Now you can really see the form of the figure. Draw the shape of the sword all the way through the hand. This will help you form the hand so that it really looks as if it is gripping that sword.

4 Add more costume details. Always add detail work toward the end of the process. Details fit on clothes, clothes do not fit on details!

5 Erase line work you don't want or don't need. Add complicated folds and swirls to the shape of the hair.

6 Some artists prefer to have the pencil drawing as tight and clean as possible before inking. Some artists don't. Tight pencil drawings make some art seem stiff, but some people need tight drawings to help with the inking process. I prefer to have some flexibility, so I almost always ink on rough drawings. All fine detail work is done at this stage.

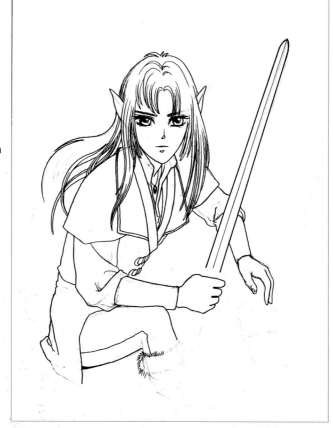

Final Jarl

Here is the final drawing of Jarl as a manga elf! I added the background using Japanese tone sheets; but you can also draw it by hand or leave it blank. He's such a nice-looking elf, he doesn't need any competition from a sunset!

The original photograph could inspire one hundred looks. Jarl could be an elf, or he could be holding a baseball bat or a frying pan. Try to think of how many different ways you can use each photo you take.

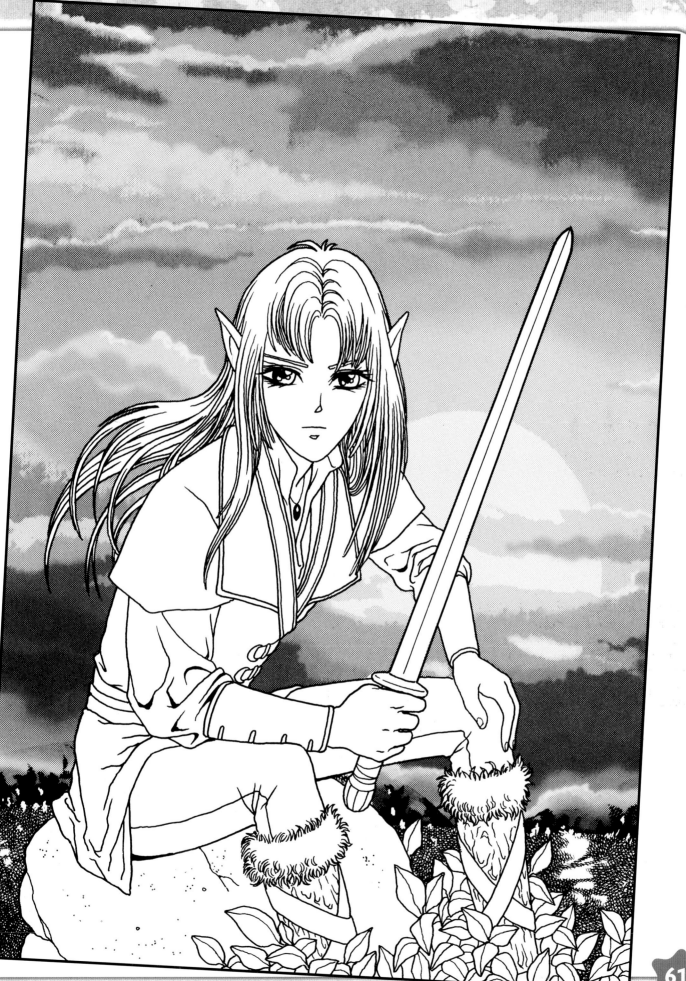

61

It's All in Your Hands

I am going to give it to you straight. The human hand is one of the most difficult things there is to draw well. Not only does it have more moving parts than any other portion of the body, it has an ever-changing gestural range. You are not going to learn everything you need to know about drawing the hand from a book. The only way to really become good at it is to observe and practice. However, since the manga hand is simplified and stylized, particularly the shoujo manga hand, I can give you this primer and go over some stylistic points.

1 Draw a diamond. The palm is the same length as the fingers, so this step will establish symmetry of the form.

2 Draw two long curved half ovals over the outer edge of the diamond. Erase the straight lines of the diamond and draw a line at the very bottom third of the bottom half of the form.

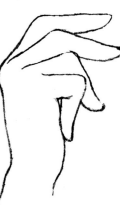

Draw Hands With Volume

The hand is not flat. Give hands the impression of volume. Draw the knuckles to curve around the top of the hand. Notice that when the hand is drawn as a fist, the third knuckle is always shown, whereas when the hand is open, the third knuckle is often not drawn at all.

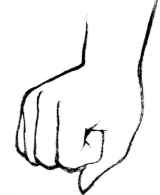

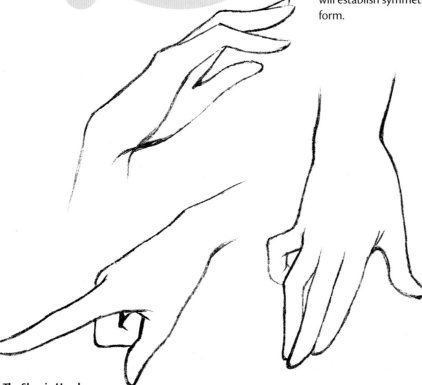

The Shoujo Hand

The shoujo manga hand is drawn much more simply than a real hand. Artists often drop the second joint of the finger and lengthen the digits to make hands very long, slender and graceful. Fingers don't have to be absolutely realistic in shoujo manga, but knowing how to draw realistic hands will make you a better manga artist.

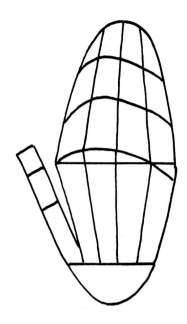

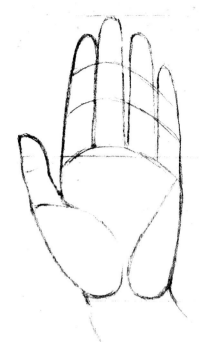

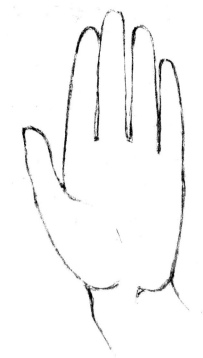

3 Draw a series of lines from the top of that lower line, then to the center line, and again to the upper curve. If you feel your own hand, you can feel that the shape of those lines closely approximates the position of your bones. Draw three curved lines for the joints of the fingers. Notice that they are tilted. Your fingers are not all the same length and the joints of the outer fingers curve downward from the middle finger. Placing the joints of the thumb can be tricky because the thumb sticks out. Don't worry about being perfect right now. Manga hands are rarely drawn realistically. But the skill will serve you in any kind of drawing you may do.

4 Flesh out the fingers, drawing smooth curves of muscle around them. At this stage, drawing is almost as simple as connecting the dots! If the framework is solid, your finished drawing will be solid. Pay close attention when placing the large masses of hand muscle in the palm.

5 Erase your guidelines and clean up your drawing.

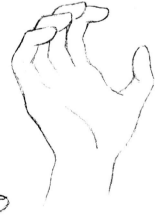

Hand in Profile

The profile of the hand is tricky. Placing the thumb accurately is essential. Try drawing your own hand or even tracing around it and placing the guidelines along the traced form. Practice, practice, practice!

The Disappearing Knuckle

In the clawlike hand pose, the third knuckle gives the hand a harsh appearance, but in the open hand, the third knuckle is not drawn (in order to emphasize those long, slender fingers). To use the knuckle or not to use the knuckle is largely a matter of style. Some manga artists almost never draw it while western comics artists rarely leave it out. In animation-style drawing, the third knuckle is usually left out as well.

ABSOLUTELY FABULOUS: FASHION and STYLE

Next to drawing the face well, drawing great clothes and hair is essential to creating a great shoujo look. Everything you learn here can be applied to any kind of drawing or painting. Style is purely a matter of taste and everyone can create their own. It's always good to learn from other people, other times and other places, as well as creating your own unique looks. You can transport people to distant lands simply by decorating your characters with the right costumes and hairdos!

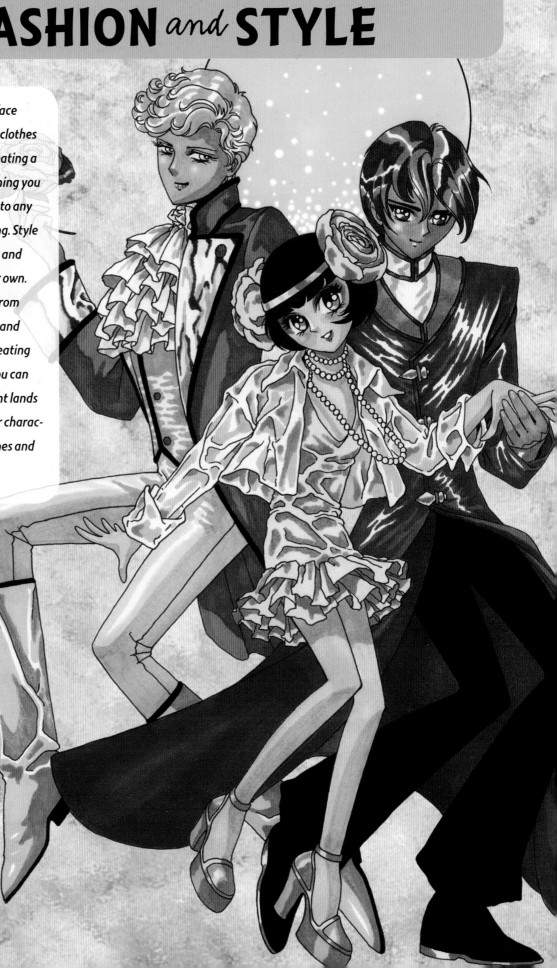

The seven basic types of folds are the most important things to learn in order to successfully draw clothes. Cloth has no real shape of its own. It morphs with its environment. Wear it, drop it, put it on a hanger, it becomes something different every time. But no matter what you do to it, it tends to respond in seven different ways. Learn these simple fold types and you are well on your way to drawing just about any type of clothing look.

Practice all the folds on this page. Copy them exactly, then develop your own variations.

The Drop Fold
Created anytime cloth drops in a free fall.

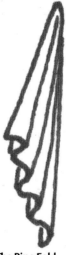

The Zigzag Fold
Twisting back and forth, used for scarves, sashes, any long trails of cloth.

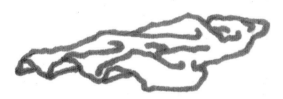

The Inert Fold
Cloth just laying around without much tension or twist.

The Pipe Fold
Clean, crisp folds shaped like pipes.

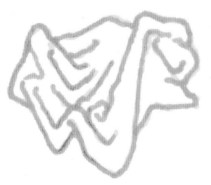

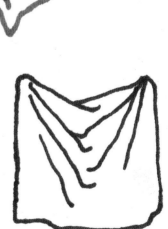

The Spiral Fold
Cloths twisted around an arm or a leg.

The Halflock Fold
Folds that twist in and out of one another, often on clothing that is draped over the knees.

The Diaper Fold
Two points of tension create a V-shape.

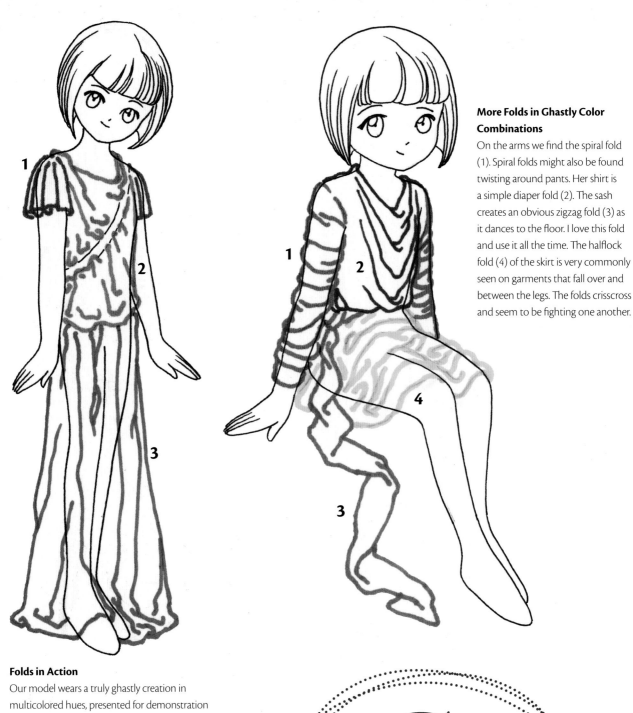

More Folds in Ghastly Color Combinations

On the arms we find the spiral fold (1). Spiral folds might also be found twisting around pants. Her shirt is a simple diaper fold (2). The sash creates an obvious zigzag fold (3) as it dances to the floor. I love this fold and use it all the time. The halflock fold (4) of the skirt is very commonly seen on garments that fall over and between the legs. The folds crisscross and seem to be fighting one another.

Folds in Action

Our model wears a truly ghastly creation in multicolored hues, presented for demonstration purposes, only. Who would be caught dead in this? Regardless, you get a good look at three different types of folds. At her shoulder, the aptly named pipe fold (1). Obviously, it looks like little pipes. The green folds across her body are inert folds (2), created by the volume of her tunic. They are just sort of laying across her chest, not doing much. The skirt is a drop fold (3). Any simple garment that just drops from the shoulders or waist may create this kind of fold, which swings and sways from one direction to another.

DRAW THE FIGURE FIRST

Draw the body underneath the clothing first. The body affects every aspect of the shape of the cloth.

You want to be adept at drawing all the different folds because the types of folds on your figures change constantly as they move.

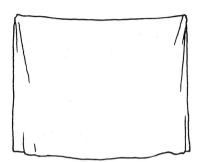

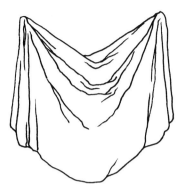

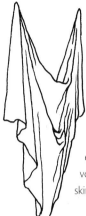

It's Forever Morphing

All scrunched up, the cloth has morphed again. You have pipe folds and very crisp diaper folds. Use these folds on the back of elaborate gowns, on veils, voluminous capes and trailing skirts.

Cloth Is Nearly Shapeless

Here's another look at the quality of cloth. Simply laid out, the cloth doesn't have much shape of its own.

Movement Gives It Shape

As you move the ends of the cloth together, a clean diaper fold is created. This is the kind of fold you use on a tunic or cape.

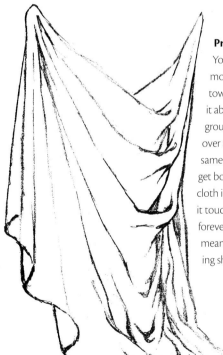

Practice With a Towel

You never lack for good models when you have a towel in the house! Drape it about, throw it on the ground and draw it over and over again. It never has the same shape twice! You can't get bored drawing clothes. The cloth is always affected by what it touches and by gravity, so it forever changes shape. That means it is also forever changing shape on your body.

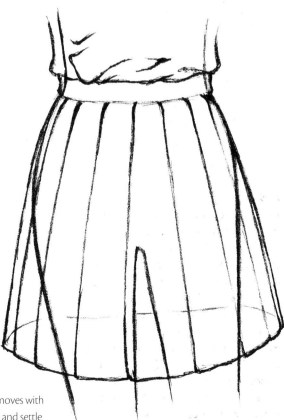

All Clothes Move With the Figure

Even a stiffly starched and pleated skirt moves with the figure. Pleats gently roll over the hips and settle about the body.

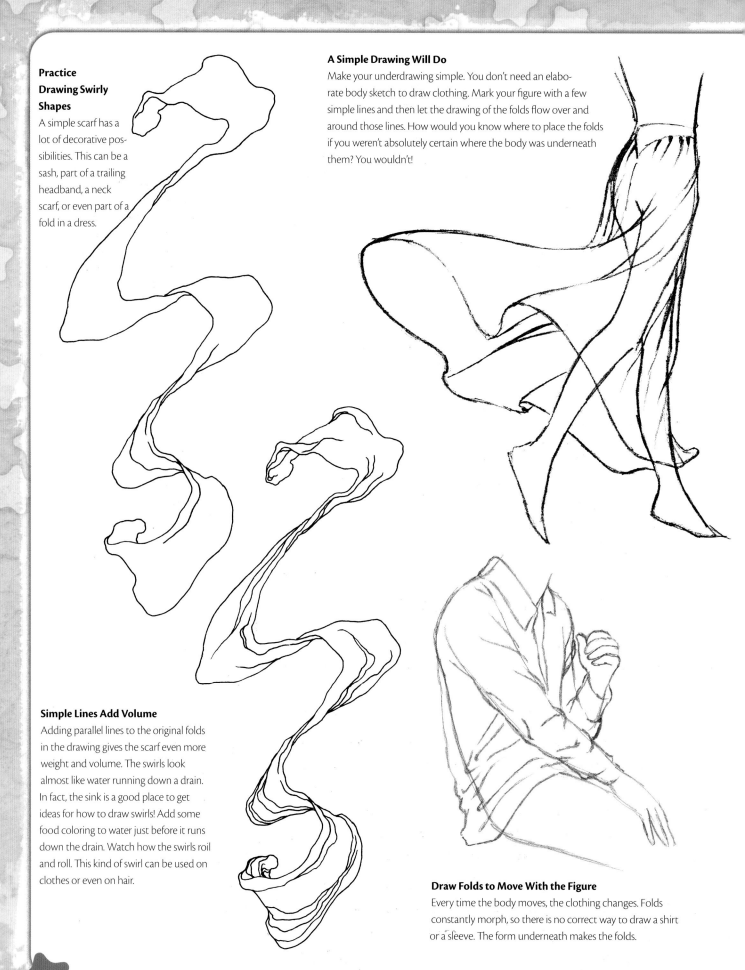

Practice Drawing Swirly Shapes

A simple scarf has a lot of decorative possibilities. This can be a sash, part of a trailing headband, a neck scarf, or even part of a fold in a dress.

A Simple Drawing Will Do

Make your underdrawing simple. You don't need an elaborate body sketch to draw clothing. Mark your figure with a few simple lines and then let the drawing of the folds flow over and around those lines. How would you know where to place the folds if you weren't absolutely certain where the body was underneath them? You wouldn't!

Simple Lines Add Volume

Adding parallel lines to the original folds in the drawing gives the scarf even more weight and volume. The swirls look almost like water running down a drain. In fact, the sink is a good place to get ideas for how to draw swirls! Add some food coloring to water just before it runs down the drain. Watch how the swirls roil and roll. This kind of swirl can be used on clothes or even on hair.

Draw Folds to Move With the Figure

Every time the body moves, the clothing changes. Folds constantly morph, so there is no correct way to draw a shirt or a sleeve. The form underneath makes the folds.

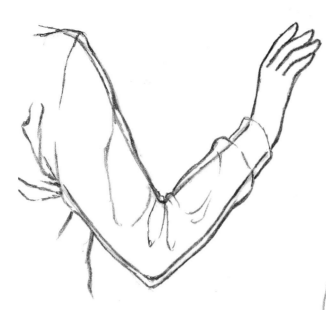

Don't Forget About Texture
The texture of cloth also changes the shape of the fold. Draw sweatshirts to reflect the thicker, firmer feel of the cloth. Make the folds wrap around the arm and cling to the body. Create heavy loops.

Smooth Cloth Swoops
Silken smooth cloth creates sweeping, graceful folds, without crispness or harsh lines. Draw these folds as air-light swoops that glide around the body. There is no one correct way to draw a sleeve because the type of cloth and the turn of the body will always change the drawing you do. Folds come first!

NO GIRLS IN SAILOR SUITS HERE

Any book on drawing manga can show you how to draw girls in sailor suits, so we're not going to bother with that here. If you learn to draw folds correctly, you will be able to draw any kind of outfit well. Moreover, if I spent a lot of time showing you the latest fashions, by the time the book was published, they would already be out of date!

Instead, do what pro artists do: Keep files of fashion magazines on hand at all times. If you are near a major city, buy the latest fashion magazines from Paris or Japan. The clothes are so far ahead of trends that you will stay one step ahead of your audience. When the year is over, toss the magazines and get new ones so your clothes will always be contemporary. If you can't get high fashion magazines, go to the Internet or the library to do your research.

You should also keep reference files on historical costume, as well as files of reference material on clothing from more recent times, such the fashions from the 1960s, the 1980s and so on.

Historical

omplicated historical costumes may seem intimidating, but everything becomes easy when you break the problem down to its essential elements. No matter how clothing is constructed, everything breaks down to form and fold.

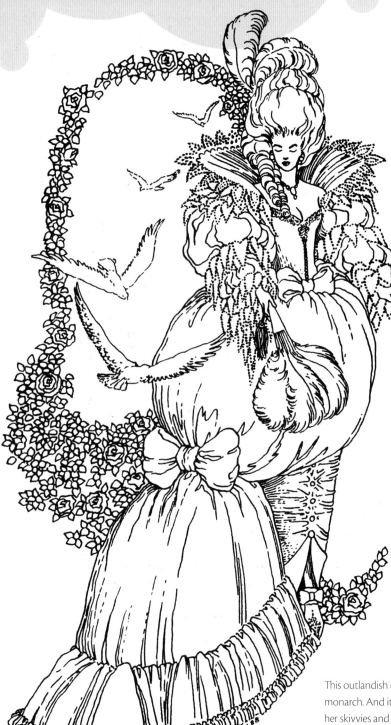

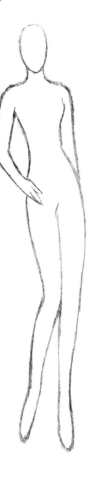

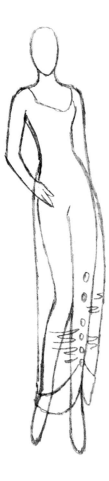

1 Without all those clothes on, she is pretty tall and thin. Begin with a thin outline.

2 Draw in the tight pencil skirt and the buttons beneath those poofy overskirts. The buttons create small folds all along the middle seam.

This outlandish creation looks like it came out of the salon of a French monarch. And it looks pretty hard to draw! Let's strip this girl down to her skivvies and see what's going on under all that poof and lace.

ART FROM *A DISTANT SOIL* © AND ® COLLEEN DORAN 2006

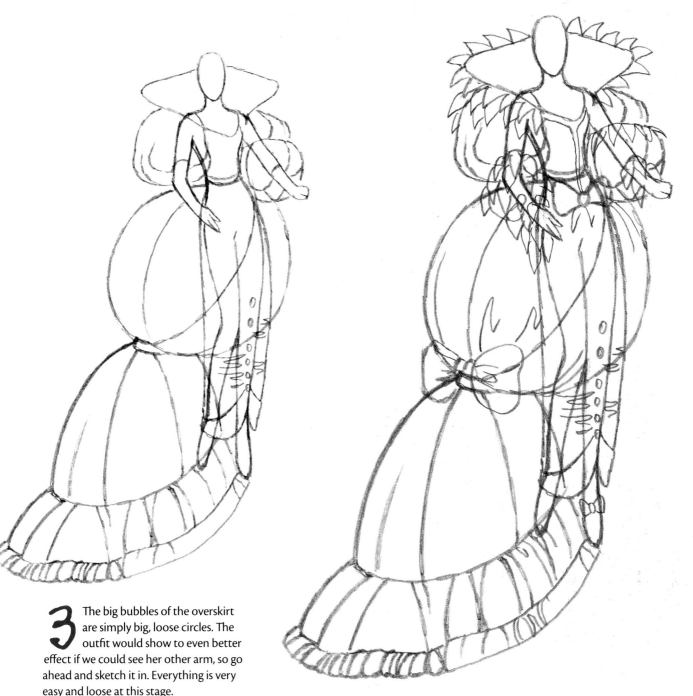

3 The big bubbles of the overskirt are simply big, loose circles. The outfit would show to even better effect if we could see her other arm, so go ahead and sketch it in. Everything is very easy and loose at this stage.

4 Add all the final elements. Pencil in triangles for the big lace drapery on the sleeves and collar. Then make little dots with ink all along the lines of the triangles. Erase any lines you don't want to ink, and go to the final work.

Fantasy

Drawing great fantasy outfits is one of the pleasures of manga. You'll love designing funky costumes! Much of it is about drawing details, like these spiky things that fly up from the shoulders. I use these on a lot of my costumes. They are not at all hard to draw.

GIRL TO GRRRL TIP

We all love fabulous costumes, and when I am doing a single illustration, I go wild with the detail. However, when you are drawing an entire manga, you have some planning to do because those fancy, eye-catching costumes are time-consuming. I once had to draw a character who could replicate himself, and I made the mistake of drawing him in a patterned sweater. After I drew that sweater about one hundred times, I wanted to burn the whole thing! So save the most complex and complicated costumes for illustrations and shorter scenes. Use simpler outfits for longer scenes.

1 Start with a series of simple, uplifting lines like this.

2 Add lines parallel to your original lines. Already, you can see how easily this look comes together!

3 Ink in the lines. Let some overlap and weave through each other. This looks very complex when finished but is surprisingly easy to draw!

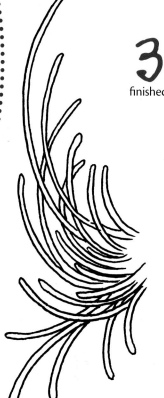

These are outfits that are much easier to draw than they would be to wear! Gravity-defying details and rich embroidery give your costumes an alien, ethnic sensibility.

ART FROM *A DISTANT SOIL* © AND ® COLLEEN DORAN 2006

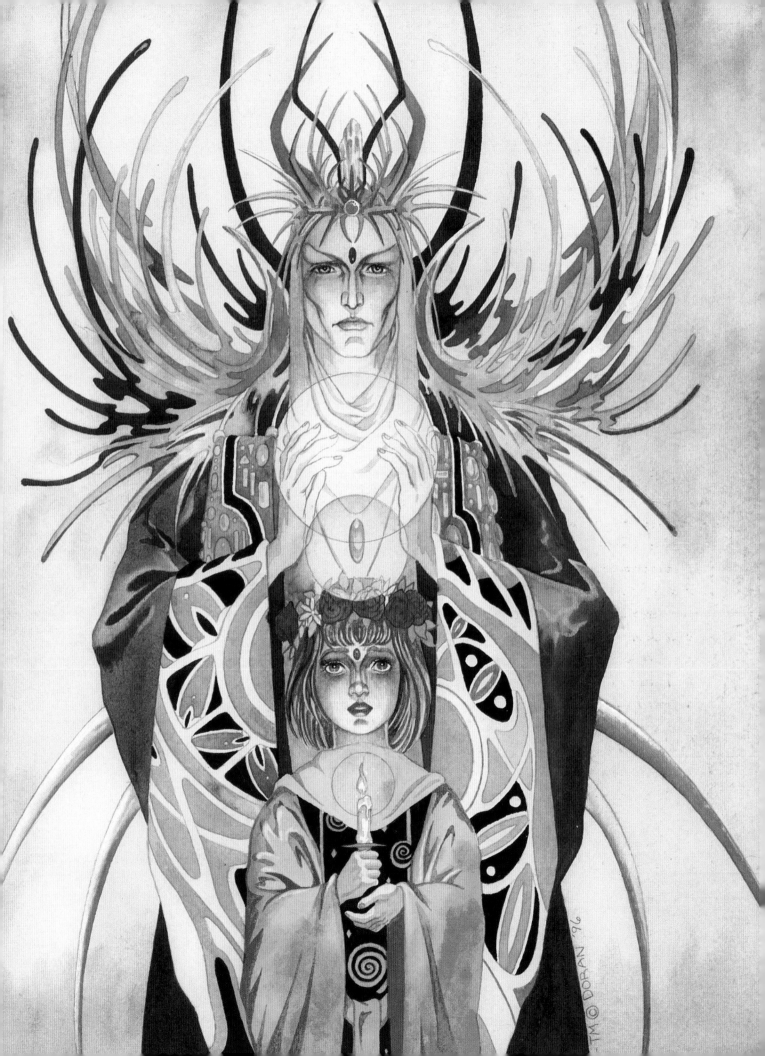

SIMPLE LINES AND SHADOWS FOR DEPTH

Creating depth in your drawings is surprisingly easy, even on complicated forms. Just remember the simple folds you learned on page 65, keep your lines simple, and fill in the shadow areas before anything else.

Create Complex Clothing With Simple Folds and Lines

This complex costume is a collection of diaper folds and inert folds. The tight bodice is a tiny series of zigzags. Draw the lines simply and cleanly. Very little is required to give even the most elaborate costume a sense of volume.

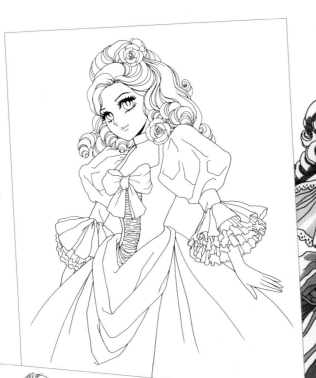

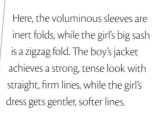

Here, the voluminous sleeves are inert folds, while the girl's big sash is a zigzag fold. The boy's jacket achieves a strong, tense look with straight, firm lines, while the girl's dress gets gentler, softer lines.

Color Shadow Areas

Areas of the clothes that go out from the body are closer to the light. Leave those blank. Color only the dark areas, establishing the shadows in monochromatic tones.

Some manga artists go no further than this with color. A monochromatic scheme is sophisticated and looks almost like an anime cel. The final art is on page 14. Much of the work of any color drawing is done right here. Establishing shadows gives your art a sense of solidity.

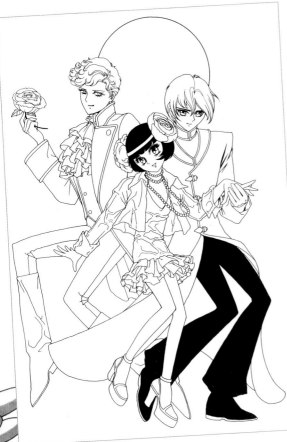

Transparent Cloth

For transparent cloth such as the gauzy jacket the girl wears, break up your drawing line to show only portions of the body beneath. A big, sweeping coat with a continuous line may be too much to handle freehand, so get a curve template and use it to rule the wispy, delicate lines of the girl's clothes.

Color the Shadows

Use gray and cool blue for the bright white shirt, and a deep vibrant red for the darkest area of the deep orange jacket. Drop in touches of deep golden yellow for the air-light flapper girl's dress. Leave spots of the jacket completely white to show transparency. The finished art is on page 64.

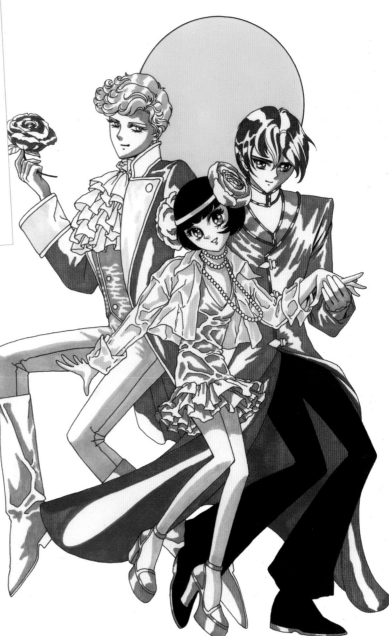

If there is one thing that drives Japanese readers crazy when they see original English language comics, it's the badly drawn kimono. The kimono is a complicated subject and to draw it well requires diligent study. There are many types of kimono. Most westerners have never worn one, so they don't understand how they are made or how they fit on the body.

In my humble opinion, the woman's kimono is extremely uncomfortable! Underneath the sleek exterior is a lot of binding and the obi (the wide sash) is an immobile, many-yards-long knotted belt. To properly teach you how to draw it would take an entire book. Here are some basic tips to get you started!

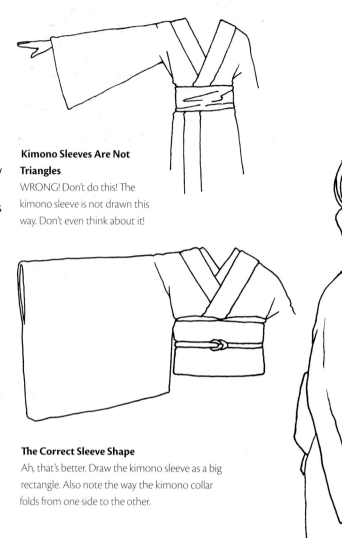

Kimono Sleeves Are Not Triangles

WRONG! Don't do this! The kimono sleeve is not drawn this way. Don't even think about it!

The Correct Sleeve Shape

Ah, that's better. Draw the kimono sleeve as a big rectangle. Also note the way the kimono collar folds from one side to the other.

Absolutely NOT

AGH! My eyes! Please don't do this! I see this mistake all the time. Japanese characters do not tuck their hands into their sleeves. The opening of the kimono sleeve is actually quite small. Most of the sleeve is sewn shut, and kimono sleeves tend to be a bit short against the wrist. This pose is used for Chinese characters and costumes, not for Japanese characters and costumes.

Keys to the Kimono

We all love the brightly colored elaborate kimono with big hair decoration we see on geisha, but even real geisha don't wear those. Only trainee geisha called *maikos* wear those. True geisha would wear something as simple as this, with understated accessories of the highest quality.

The mature lady's kimono has simple lines. Resist the temptation to add a lot of decorative wrinkles and folds. The goal in wearing the kimono is to achieve a perfect, graceful line.

The Obi Belt

The obi belt is elaborately and tightly braided, and tied with a thick knot.

Staple Accessory

Beautiful fans are a staple accessory. Sometimes they are decorated with ribbons and tassels.

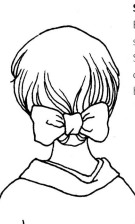

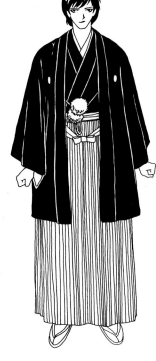

The Gentleman's Kimono

This a sober affair. There isn't even an obi to lighten it up. The big, black jacket is decorated only with a tiny family crest. The voluminous pants are plain or striped culottes. The belt/sash is very simple but hard to tie and is sometimes decorated with a pom-pom and elaborately woven braid.

Socks and Sandals

The split-toed socks are necessary for this common type of sandal worn with kimono. A proper lady in kimono walks with toes turned inward. The kimono skirt is tight and restricting and the mincing gate resulting from the skirt and the pigeon-toed walk is considered very feminine.

Keys to the Kimono Back

The kimono back has the same clean, uncluttered line as the front. The interesting points on the back of a lady's kimono are the big obi bow and the dropping neckline.

The obi bow takes many shapes and is another one of those things you have to study to master. The obi pictured here looks like a big, hollow pillow, but other obis look like big bows or flowers.

The lady's neckline makes a crisp, diaper fold. It drops in the back because a long, smooth neck is considered very beautiful and the dropping neckline gives the illusion of length.

Common Crests

The crane motif is common in Japanese art and this stylized picture would be a perfect family crest for a man's kimono.

Common Decoration

The chrysanthemum is also commonly used in Japanese art, and you will find it decorating many pictures of kimono and obis.

Kimono Couture

This is a very expensive modern festival kimono, the kind that might come from a top designer. This kind of highly decorated kimono, with fur capelet and accessories, could not be worn by an adult. Loudly colored, highly decorated kimonos are for fashionable, wealthy, youthful girls.

GIRL TO GRRRL TIP

Remember that in Japanese culture, elegance and wealth aren't necessarily indicated by a lot of decoration. Simple, superior craftsmanship and high-quality materials denote taste and style.

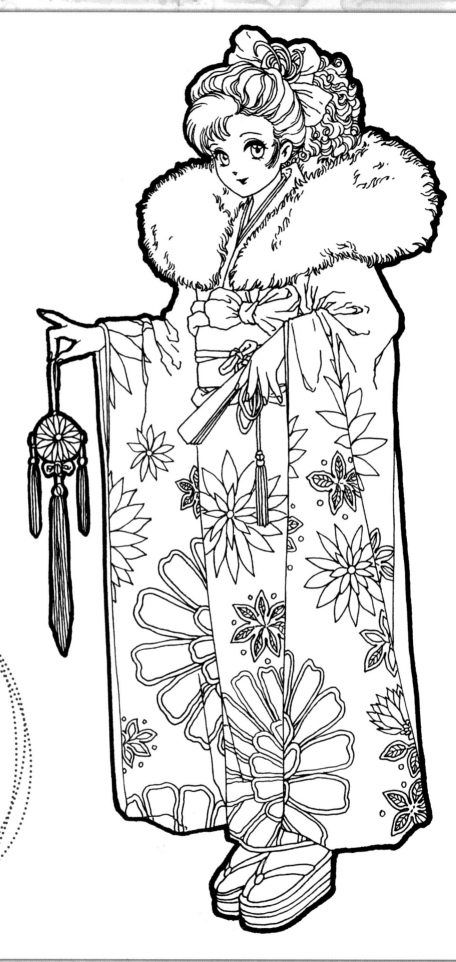

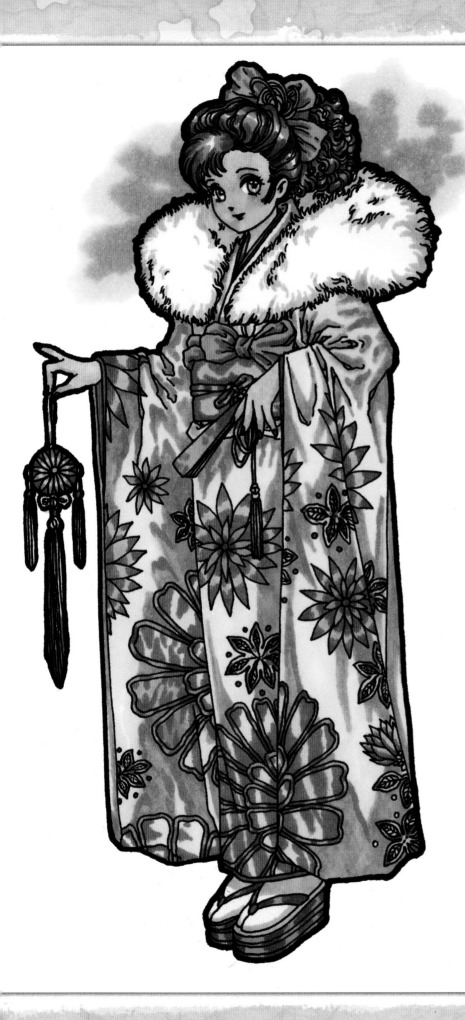

Vibrant Finished Color Drawing
You don't need a lot of color to create form—very pale yellow next to the gold, hot pink and pale pink, as well as yellow and orange for the flowers creates eye-popping, jewel-like effects. The bright orange flowers are simply orange and yellow, the same yellow used on the rest of the kimono. The obi sashes and hair ribbons are just two types of pink; the leaves, two different greens. The decorative purse is of the same colors as the kimono.

Ruffles and Flourishes

While kimono are known for their grace and simplicity, western costume, especially historical costume, is an endless array of lace, flounces and elaborate detail in dizzying variety. These flourishes return to fashion periodically and the current Loligoth fashion craze among young Japanese has countless girls and guys dressing like Victorian dolls. You'll need to brush up on drawing ribbons, lace and ruffles to capture this popular look to which entire magazines are devoted. It doesn't hurt to learn these tips for other types of historical costume drawing, too!

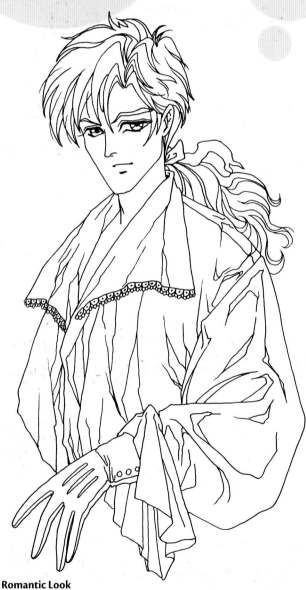

Romantic Look

The Vampire Lestat might have worn a shirt like this, but you can find rock fans and Loligoth guys walking down the streets of Tokyo in these romantic shirts, too!

GLOVES

To draw an elegant gloved hand, draw a simple hand outline.

RUFFLES

Ruffles appear all over shoujo manga. They look complicated, but they are just variations on the simple pipe fold. (See page 65.)

The basics to the ruffle are quite easy to see. Draw bell-shaped triangles.

LACE

Lace looks difficult, but it is actually one of the easiest things to draw. It is simply time-consuming, though, because it has a repeating, complicated pattern. Most manga artists leave this sort of thing to assistants or use mechanical lace. But drawing your own lace looks much nicer.

Draw a series of scalloped shapes along the line of the edge of your garment. The shapes should reflect the inner and outer movement of the line.

EYELET LACE

This looks great on all kinds of feminine clothes and historical designs. It's also a tad easier to draw than the lace style above. You can make up your own lace styles, too. Experiment with other shapes. Just remember that lace usually keeps a consistent, repeating pattern.

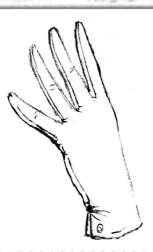

2 Add a few crinkles at the knuckles and the wrist. Indicate the lines of the seams of the glove down the side of a few fingers.

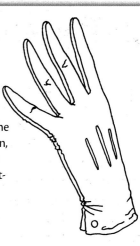

3 Add stitching details on the back of the hand and clean, crisp lines to finish off the drawing. You may want to add buttons to the wrist of the glove.

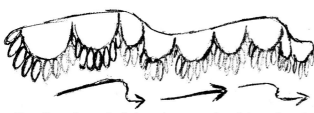

2 Ruffles are not flat. They wind in and out along the line of the garment. Don't forget to draw the inside edge of the ruffle.

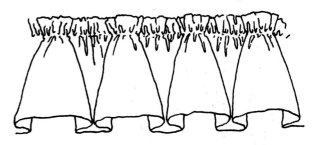

3 Add tight, crisp folds at the top of the exposed seam and clean, loose lines along the bell of the ruffle.

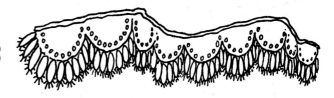

2 Draw tiny ovals all along the outer edge of the scallops. It looks like lace already!

3 Cleanly trace over your pencil in ink. Add tiny circles and tiny feathered lines along the edge of the lace. Keep the design consistent as you go along. None of this is difficult, it just takes time to do it. I've spent more time drawing the edge of a lace handkerchief than an entire figure!

1 Begin with the same simple scalloped edge.

2 Add tiny scoops to each edge, then little eyelet holes and that's it!

Drawing Hair

Shoujo illustrations use hair as a major decorative feature. Drawing hair is quite simple. Hair is a mass, not a series of lines. Break the hair down into chunks. The smaller and simpler something is, the easier the form is to see. Add details on top of the form. Always think of form first. These short hairstyles look great on boys and girls. You can also modify them with long falls of hair in the back, ponytails, etc. Get used to drawing short hair before you move on to more complicated looks.

BASIC HAIR

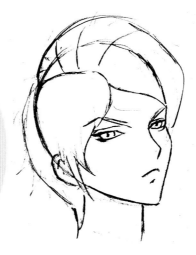

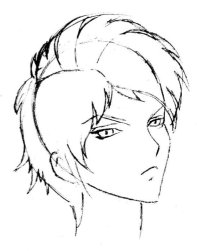

1 Draw the head following the methods in chapter 1. Do not draw the hair without drawing the skull first. Artists make this mistake all the time and what you get is a lot of hair and no brains underneath. Hair fits on top of the head, not the top of the face.

2 Break down the chunks of hair starting at the part. Don't worry about making a clean drawing. Some of your scribbles might look cool and you may want to use them in the final work.

SPIKY

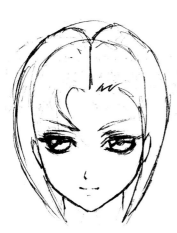

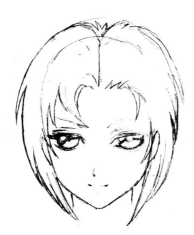

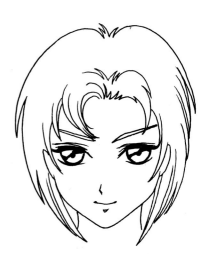

1 Modern manga hairstyles are often spiky. Add tendrils to frame the face. Draw the style so that it flows out of the part in the hair.

2 Don't worry about being too neat. No real artist draws like that. Let your pencil bounce around. It might give you ideas!

3 The only time you need to worry about being tidy is when you finish.

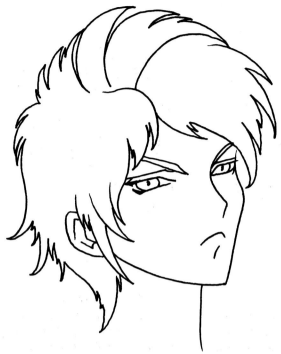

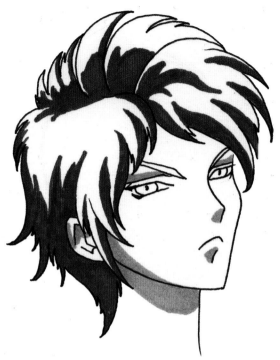

3 Ink in your drawing and clean the stray lines. Leave your drawing open for color. Spiky wisps of hair are a popular shoujo style.

4 Color in the shadows that appear opposite the light source. Leave large white swaths of the hair blank for light tones and highlights.

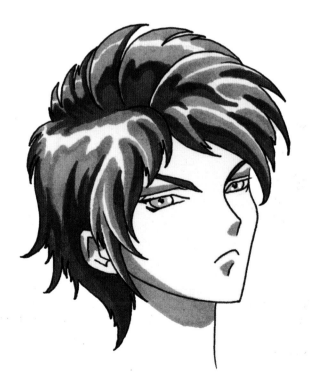

5 I used only two colors on this hair, but you can make it look more complex by deepening the tones with another sweep of your marker. The same light brown used to shadow the character's face is also used on the hair. This has an anime-style color look.

SOFT AND SPIKY

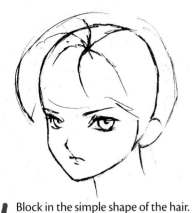

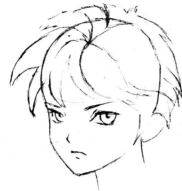

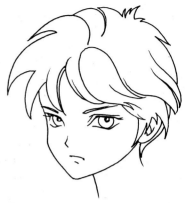

1 Block in the simple shape of the hair.

2 Start the form of the hair from the part. Shape the hair's curves like large half-moons.

3 You can make the hair spikes harsh and linear, or a little softer, like these.

CURLY OR WAVY

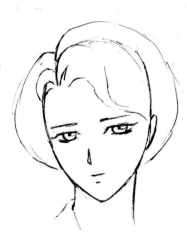

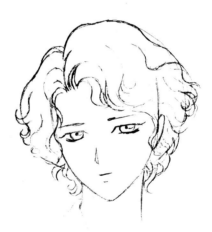

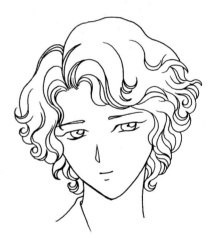

1 Again, begin with the head and form.

2 Drawing curls is trickier than drawing straight hair. Care is required or the curls look messy. Draw them in a series of S-shapes. Compose almost every curl two S-curves connected at one end.

3 Use gentle, delicate strokes of the pen. Make a few of the lines parallel to give the strands some weight.

A major illustration like this takes time, almost all of it spent on creating that big head of hair!

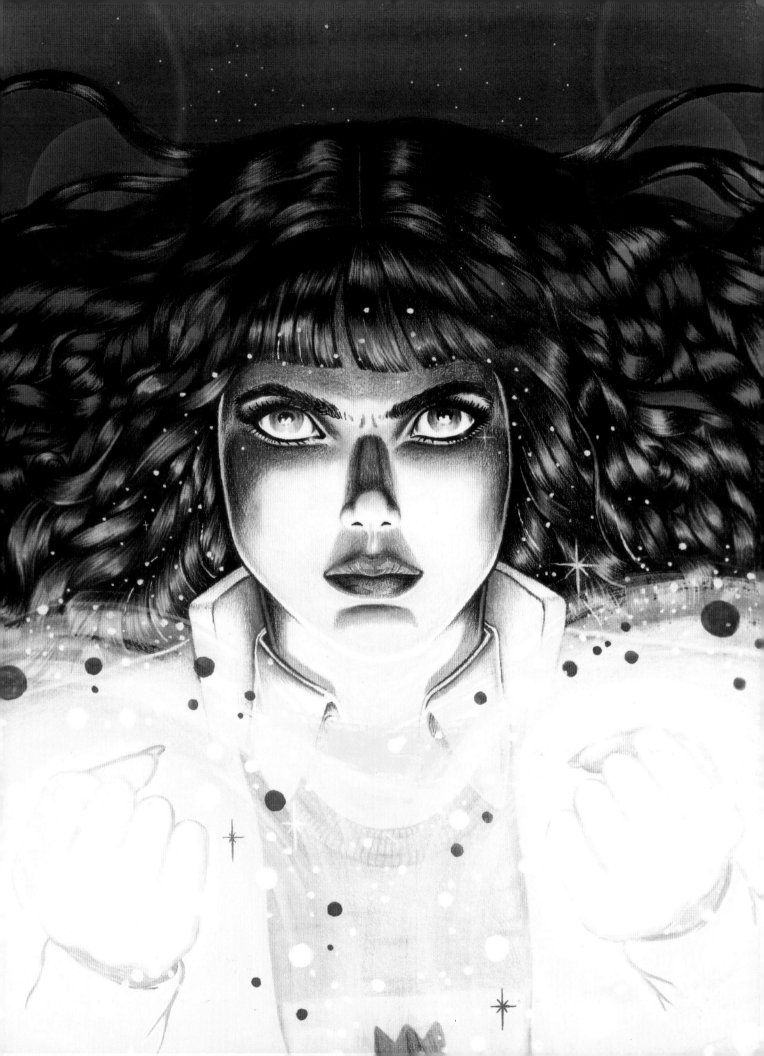

Coloring Hair

Creating a head full of glowing locks requires that you follow only a few basic tips. The real secret to these techniques is old-fashioned patience!

 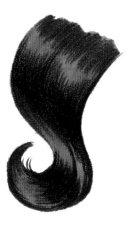

1 Begin with a simple drawing of the shape of a lock of hair. Draw them all over the head, twisting and twining around each other.

2 Color each strand of the hair. Vary colors from strand to strand. Put lighter tones on areas you want to highlight.

3 Take a black colored pencil and flick, flick, flick! Draw in each tiny strand with little twists of your hand. This takes a long time, but it looks terrific!

Another way to render hair is this technique that I used on the cover.

1 Begin with the shape.

2 Color in the dark areas of the lock of hair. Leave large white highlights.

3 Color in the lighter shade right on top of the highlights. Leave small, bright highlights blank or use a colored pencil to add tiny bright strands.

Glossy black hair is the easiest of all.

1 Again, begin with the shape.

2 Color in the black strand, leaving a large white highlight.

3 Add a wide swath of blue. It looks even prettier to add two blue tones and mix them a bit. Add black strands for detail.

☆ GIRL TO GRRRL TIP

Hairstyles change as often as clothing fashions. Most newsstands carry magazines that have nothing but hairstyles in them—girls take the photos to hairdressers to show how they want their new cut. These are great references for artists. If you stock one or two of these magazines in your studio and get new ones every year, you'll always be up to date with the latest looks.

Embellish your illustrations with jewels, twisting strands, vines and flowers. You can create incredible looks with practice and patience.

ART FROM *A DISTANT SOIL* © AND ® COLLEEN DORAN 2006

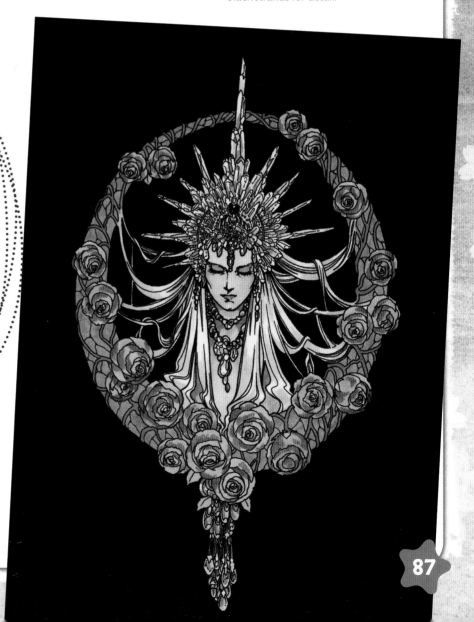

Drawing Long Beautiful Hair

Gorgeous falls of long hair are a staple of shoujo manga, and there is an infinite variety of styles. Just remember is that hair is a mass. Treat the hair as groups of tendril forms that twist and wind around each other. The beautiful sense of line in shoujo art is often shown to best effect on great hairstyles, so take advantage of that and learn to draw smooth, sinuous lines.

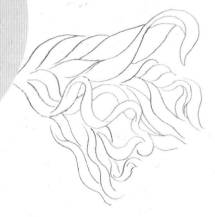

Underneath all the detail, hair locks are twisted loops that look a lot like strands of ribbon. Take a pile of Christmas wrapping ribbon off the loop and drop it in little piles. Practice drawing the looping strands to get an idea of how to think of hair in simple lines.

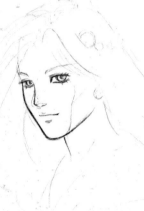

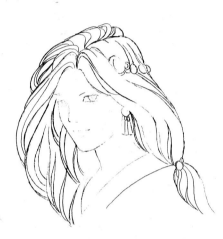

1 Remember, always draw the head before you draw the hair. Hair fits the head. Block in the basic form of the hair. Don't let it lie too flat.

2 Draw the hair in thick locks. Make them curved so they flow in graceful arcs.

3 Draw the strands right over one another and erase any lines you don't want later.

4 Clean up your drawing and tighten up details before you ink or color. For a change of pace, I colored and inked the final version in animation cel paint, leaving the lines of the hair blank. You can now finish the hair in either ink or color using the techniques you practiced on short hair.

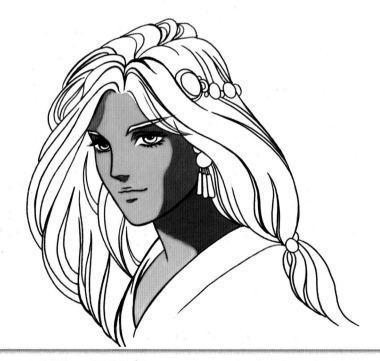

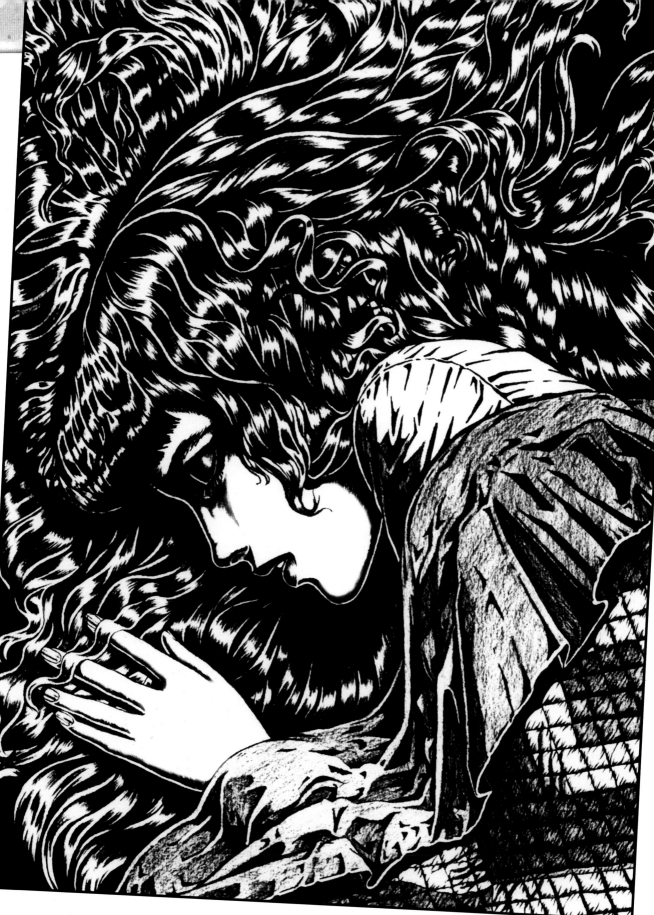

An elaborate fall of hair like this looks complicated and
difficult. But most of the work is in rendering the tiny lines
that make up a big head of hair.

The **SHOUJO STYLES**

There is no "Magical Girl" shoujo style. There is no "Historical Style." Magical girl stories, romances and dramas are genres, not styles. They are story categories and can be drawn in any kind of art style. An art style is a combination of distinctive visual features. When you look at the works of your favorite artists, you recognize them instantly because you see those particular artists have consistent ways of expressing themselves with their pictures. Manga comes in many different styles, and so does shoujo manga.

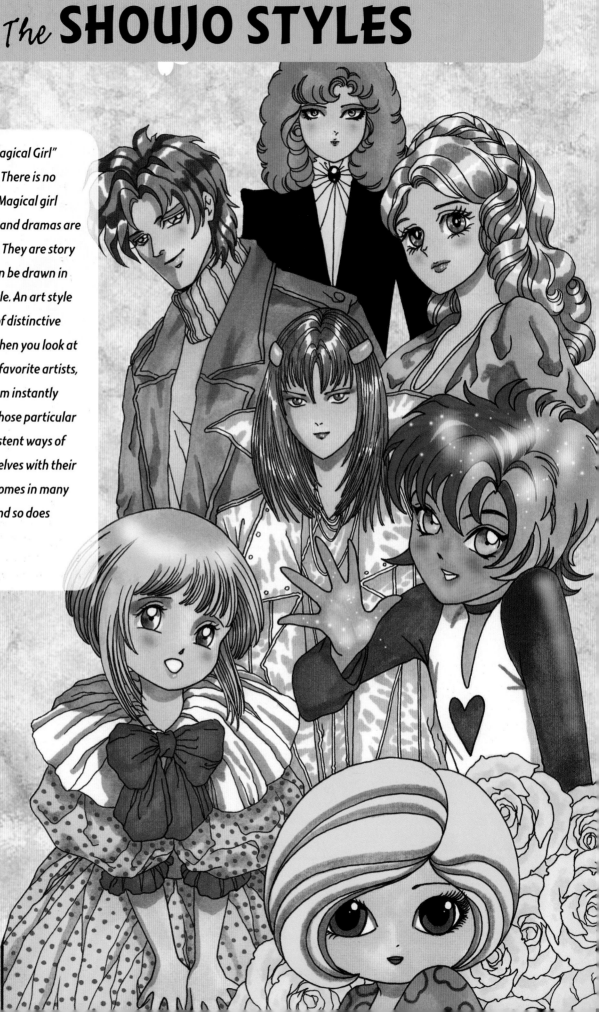

There are about seven popular shoujo looks. With practice, you will be able to draw any of these looks for yourself.

THE CLASSIC STYLE

Popular in the 1960s through the 1980s, the classic style is still used in dramas and works for children. It is a very fluid style, usually inked with a brush, and lends itself to costume dramas and historical works. The stories are clearly written and drawn. Storytelling technique combines traditional panel layouts with montage sequences to create a high sense of melodrama. The manga *Swan* (CMX Manga) and *The Rose of Versailles* (Shueisha and many others) are drawn in this style.

THE CONTEMPORARY STYLE

You learned about this style in chapter 1. It's a very popular, common look that is seen in hundreds of recent manga, though it is most associated with works by the manga artist group CLAMP. The storytelling technique does not have the sense of structure that classic manga employ, but the art is lively, energetic and often very cute.

THE RETRO STYLE

This look is completely unique and uses old-fashioned animation prototypes that place super-cute characters in bizarre worlds of wild colors and creepy situations. The combination of cute and creepy is hypnotic. *Cinderella* by Mizuno is a sample of this style. It is very popular with the young, hip Tokyo set.

THE CHILDREN'S STYLE

This look is found in a wide range of books, not just in sugary sweet epic romances. *Candy, Candy* jet-propelled the cute girl type to prominence, and ever-young heroines are still very popular. Today the style doesn't have the same degree of super-sweetness as *Candy, Candy*, but cherubic children and dazzle-eyed girls are still popular in books for kids.

THE AESTHETIC STYLE

Created by artist Mineo Maya, this is one of the most unusual styles in manga. The highly decorative, crisp drawings are used for not only disturbing horror tales but also for bizarre slapstick comedy. The storytelling technique uses more panels per page than most manga, sometimes as many as ten panels, whereas other manga average about four panels. The figures are always drawn in a stiff, almost mechanical way and are extremely elegant. Backgrounds are never realistic, whereas many manga rely on near-photorealism in their background drawings.

THE MODERN STYLE

The modern manga style is an excellent choice for teen drama, romance or for sophisticated *josei* stories (adult comics for women). Gestures and body language are quite realistic. While the figures are taller and thinner than real people, they have a naturalistic appeal. Everything about this style tends to favor minimalism. Colors are muted. Realistic backgrounds are sometimes employed, but simplicity in line is key to this look.

THE ILLUSTRATIVE STYLE

This complex, highly rendered style sometimes sacrifices storytelling clarity. There is only one goal with this look: to create beautiful, highly decorative drawings. The figure work and facial structure is very western, but the elegant lines and slight exaggerations of the facial and body type is clearly of Japanese origin. To draw this style well, you will have to learn the academic western drawing techniques, while mastering the Japanese sense of line and decoration.

CLASSIC SHOUJO

High romance, elaborate costumes and enormous, dazzling, liquid eyes typify this beloved art style that has dominated the look of shoujo manga for decades.

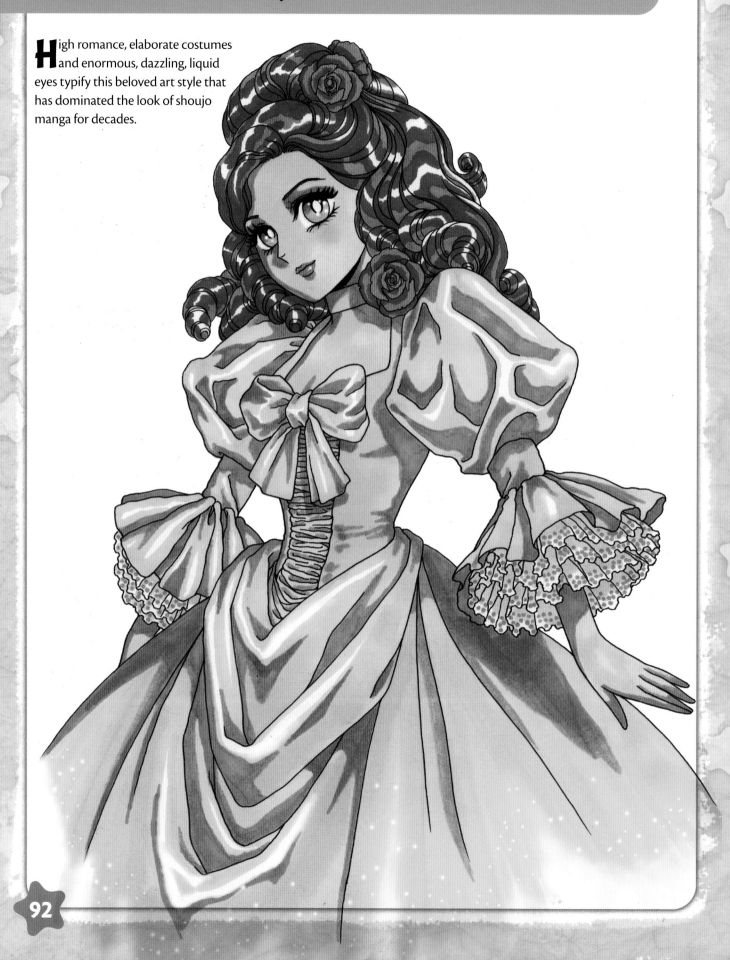

Female Heads and Faces

FRONT VIEW

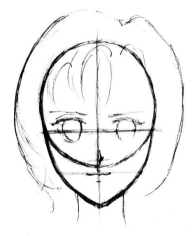

1 Draw the head with rounded jawline and delicate chin. Place the eyes at the center line. Place the nose at the midpoint below center, and mouth at the midpoint below the nose. Keep all line work curvaceous and fluid.

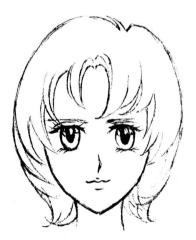

2 Use round or oval pupils. Draw lots of eyelashes with sweeping strokes. Make the mouth curved and give it a cupid's bow on the upper lip.

PROFILE

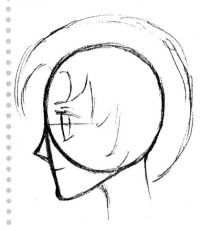

1 Add an off-center, rounded triangle to the circle. Draw the chin and nose so that they are pointed. Make the nose quite long. The chin should jut out, but the mouth sits back into the form of the head along your original triangle.

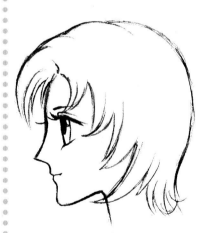

2 Make the eyelashes very long. Draw them peeking out from the other side of the profile as well. The eye is flat. Do not let it tilt back into the head. Give the nose a slight tilt and an elegant point.

3/4-VIEW

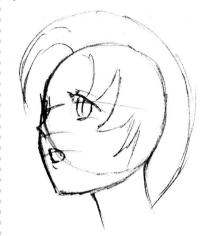

1 Draw a rounded, off-center triangle. Sketch in a pointed nose. Round the chin from this view.

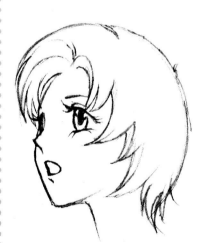

2 Keep the features smoothly lined. Ink the eyes cleanly and emphasize the eyelashes.

93

Male Heads and Faces

 his one's kind of tricky because the classic male head shape is unlike any other type you have studied so far. We'll start with the front view again.

FRONT VIEW

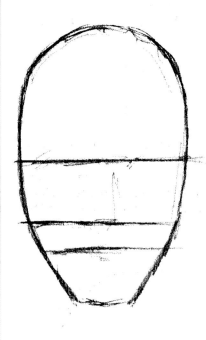 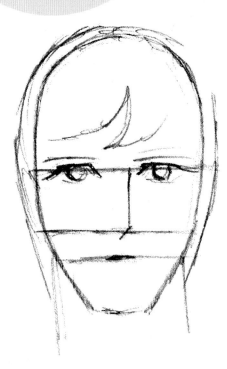 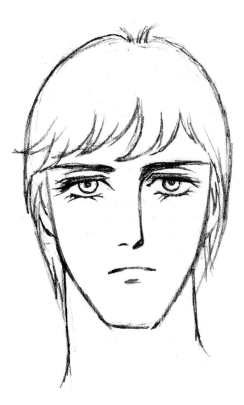

1 Make the face long and narrow and square off the chin. The length between the eyes and nose is long. Place your guidelines carefully.

2 The male neck is very wide. Draw it to fit the width of the head. Sketch in the eyes so that they are narrower and wider than the female eye.

3 This is a masculine-looking character. Make the forehead low, the nose very long and straight. Our hero has quite long eyelashes and a direct, forceful gaze. Draw the mouth with a straight, firm stroke of the pen.

3/4-VIEW

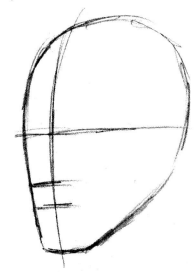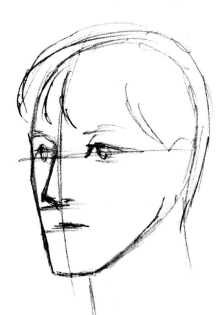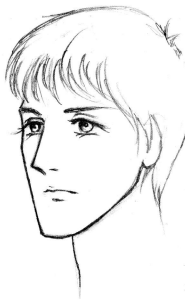

1 Instead of the delicate point you used for the female ¾-view, make the chin square. There is a short distance between nose and mouth, but almost double that distance between nose and eyes.

2 Sketch the nose to jut outward as a long, straight line. Place the mouth so it sits back into the head instead of directly under the nose.

3 The long eyelashes give this face a glamorous look, but again, he's all man. Make his iris and pupils narrow, but give him long eyelids. Draw the nose very pointed and straight. The forehead is very straight, flat and narrow.

PROFILE

There is no other manga style that uses a profile quite like this.

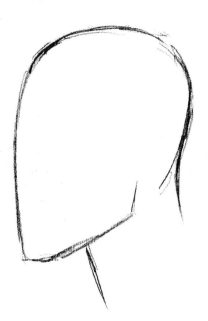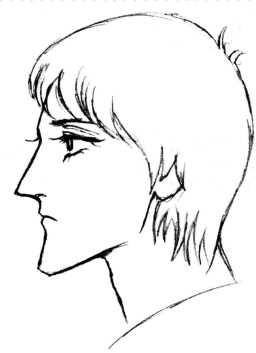

1 In profile, sketch the cranium as a narrow circle, but leave lots of room for chin and jawline.

2 Make the chin and nose very long and pointed, and set the mouth back against the guideline of the face. Even male characters have lashes that are so long you can see them from the other side of the head.

The Figure

T̲he classic shoujo figure has no hard, graphic lines that you often see in the contemporary style. The look is soft and smooth. While the figure is long and lean, it never gives the impression of harsh angles. Figures are so sinuous and graceful that they often seem as if they are floating.

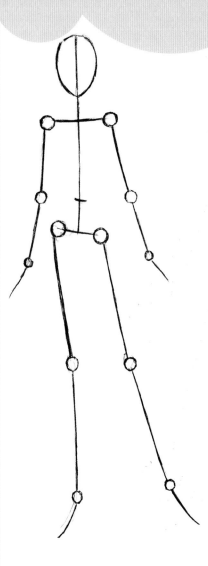

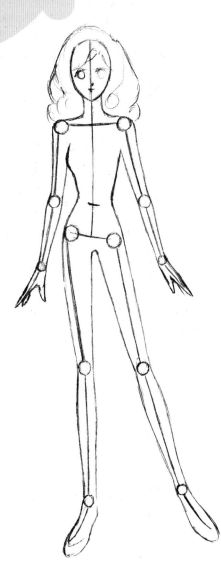

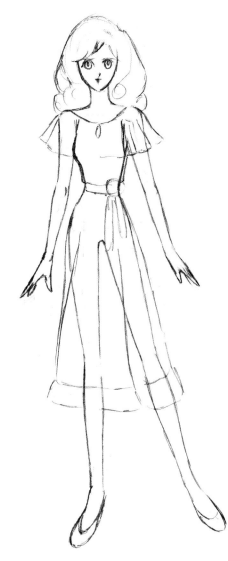

1 Start with the stick figure base. This style's figure can be very tall, 10 heads or more. The legs are quite long. For practice, 8 to 9 heads high is fine.

2 A distinctive feature of this look is that the figures often have quite long arms, large hands and large feet. I've seen figures with hands that reach their knees. You may or may not choose to make the hands and feet quite so large. The style varies from artist to artist.

3 Use flowing, feminine dresses for this look. Ribbons, bows and ruffles are common features. Characters always have voluminous hair, even if it's cut short.

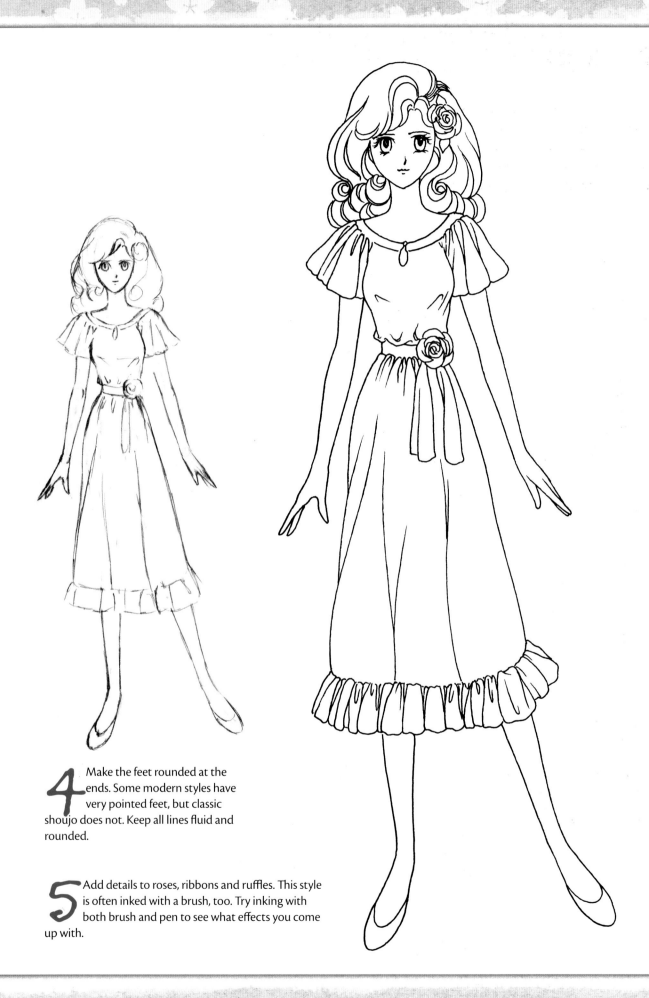

4 Make the feet rounded at the ends. Some modern styles have very pointed feet, but classic shoujo does not. Keep all lines fluid and rounded.

5 Add details to roses, ribbons and ruffles. This style is often inked with a brush, too. Try inking with both brush and pen to see what effects you come up with.

THE RETRO STYLE

The fun and funky retro style combines 1930s animation looks with 1960s and 1970s mod fashions and accessories. It is very popular on T-shirts and all kinds of licensing design.

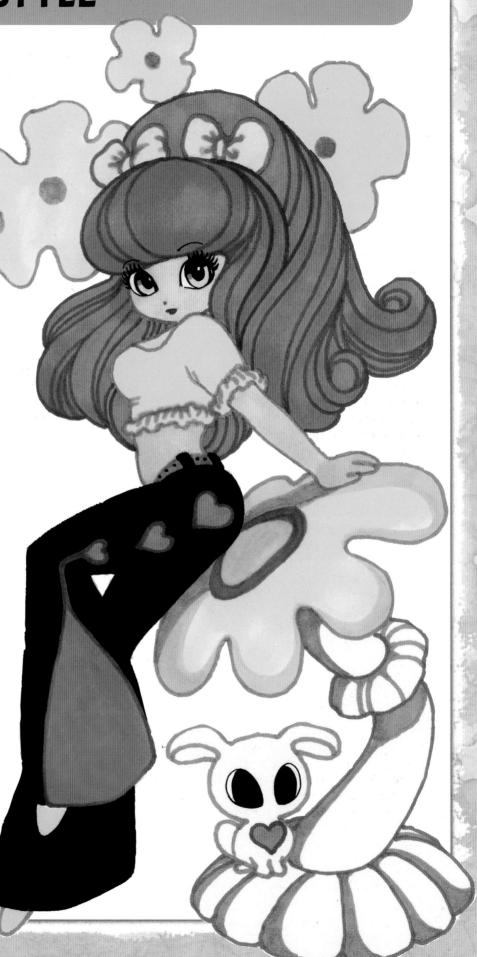

This style has a head shaped like no other. It is a slightly flattened ball and it is usually drawn in a straightforward gaze or from a ¾-view.

FRONT VIEW

1 Set the line for the eyes very low, only about a third of the way up from the chin. Make the mark for the nose just below the bottom of the eyes, with the tiny mouth a fraction below that. The shape of the eyes is the same flattened ball shape as the head.

2 Add huge irises and pupils that fill most of the center of the eye. Make big, curvy hair with a mod, sixties cut. Make the chin very small, just a little bump on the bottom of the face.

3 Ink in the eyes so that you can see the lashes and eyebrows right through the fall of the hair. Draw the hair in perfect, flowing lines. Make the nose and mouth very tiny. Draw the mouth as two, small arcs over a straight line. The face should look like a doll with a frozen gaze.

3/4-VIEW

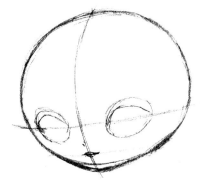 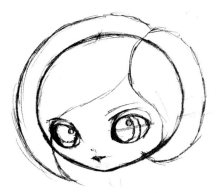 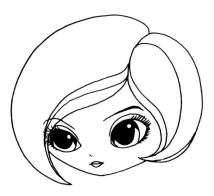

1 Draw the nose and mouth the same way you did before. Simply align them along the curve of the head. For perspective's sake, make the farthest eye a bit smaller and more oval than the near eye.

2 Sketch the hair so that it flops over the far eye. Again, draw the detail of the eye right through the hair.

3 Add a line or two to indicate the shape of the hairstyle. Ink in the eyes and frame them with big eyelashes.

99

The Figure

The retro look is curvy and full. For this style, always use the mannequin construction. Make this figure about 4 to 5 heads high.

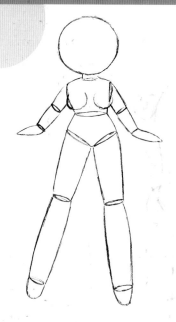

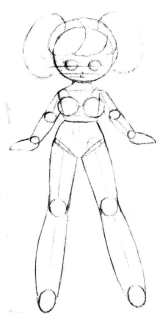

1 Draw the head like a flattened egg. The upper body is always short and plump, no more than 2½ to 3 heads high. For a taller figure, lengthen the legs.

2 Block in the hair and facial features. I've drawn the stick figure below the mannequin to show how hard it would be to get this round form over those sticks. Give the figure full hips and a bosom.

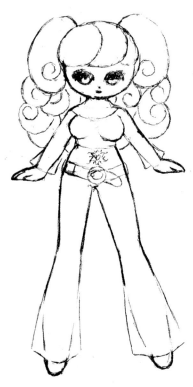

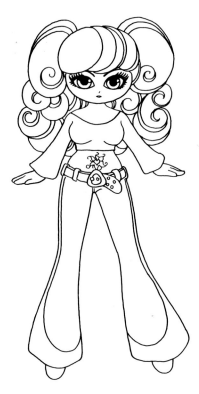

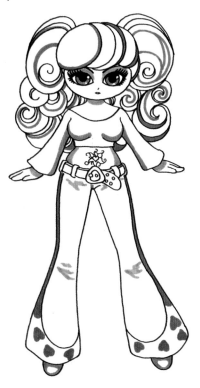

3 Erase your guidelines. Block in your costume design. Bell bottom pants and low-rider hip-huggers are popular with this look.

4 Add a tattoo to her belly button using delicate pencil swirls. Make the eyes and face doll-like with big eyelashes all around the outer edge of the eye. Add very large pupils.

5 Sometimes no dark ink lines are used to draw the figure. Instead, add a rim of dark colors all around your major ink lines to add variety.

ACCESSORIES

The retro style is festooned with mod flowers, wild shapes, strange creatures and cute companions. Go wild making up your own. They are all based on simple shapes, like this pet and flower.

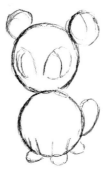

1 Stack two simple circles and lightly sketch in circles for feet, tail, ears and two big, almond-shaped eyes.

1 This basic form can be used to make the entire leafy canopy of a tree. Add a trunk to the base; and you have a tree with a funky shape. Here, we'll make a flower.

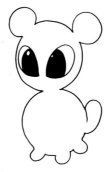

2 Ink in the simple outlines of the form and black in the pupils.

2 Link every two circles, then add a stem.

3 Add bright yellow fur to complete the picture.

3 Color in your flower with bold tones.

6 Use bold colors. Give your characters blue or pink hair. Pink eyes look very cool. Add patterns in mod shapes to clothes.

THE CHILDREN'S STYLE

Almost all manga feature cherubic children. The children's style can be the main look for an entire book as in kodomo manga, which are manga drawn for children below age eight. However, you are always going to need to be able to draw little kids in any kind of story, for readers of every age. Drawing children or childlike characters, like the fairy here, is a skill you can use anywhere.

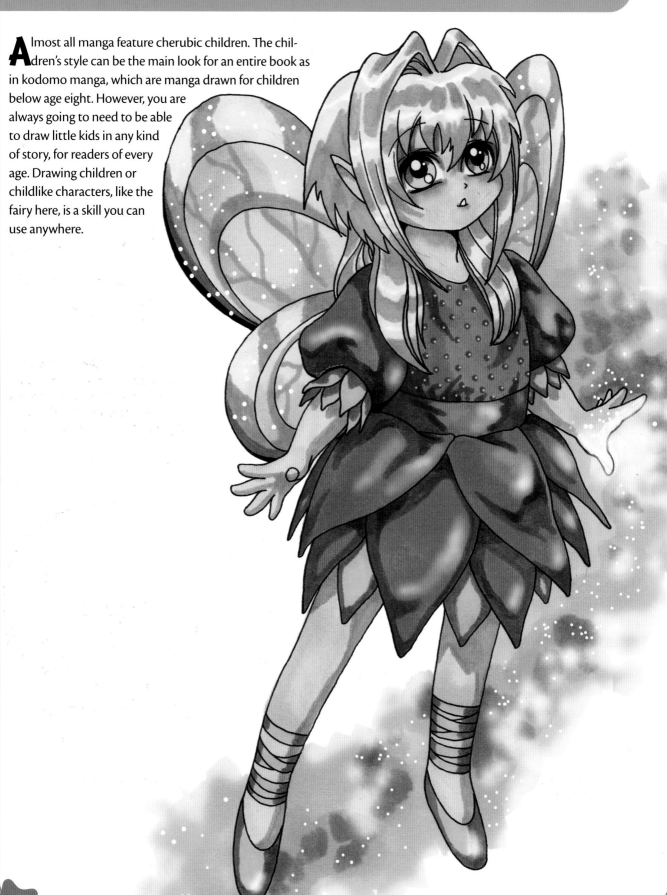

 ractice drawing these heads and faces!

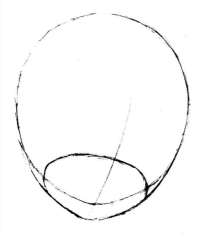

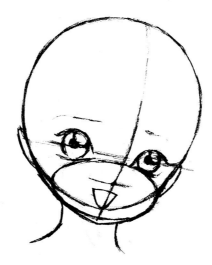

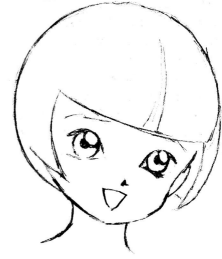

1 While the children's shoujo head is also constructed using the circle/ triangle technique, we're going to add a new drawing element to make this look even better. Add an oval to the lower portion of the face to represent the chubby cheeks that make children's faces so cute!

2 Block in the eyes, nose and mouth. Let the eyes rest on top of those big, round cheeks.

3 Erase your guidelines and look how cute this is! Add hair to rest on top of the head. Give it fullness. There is no better technique for drawing cute kids than the oval cheek placement trick.

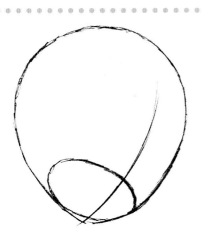

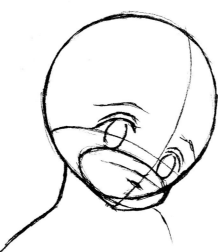

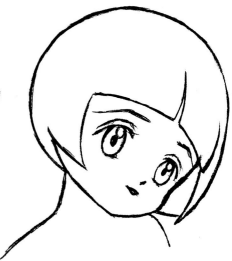

1 Let that oval roll around the face as the head turns.

2 Add your guidelines and place the features. Think of rolling and roundness when drawing this style.

3 Is this cute, or what?

We've already been through the process of drawing the head. Practice drawing these key children's shoujo features to get the cutest possible results.

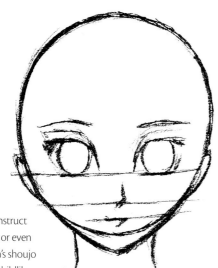

Children's Head Shape

A shorter chin, eyes set lower on the face, and the addition of an oval cheek area creates a much cuter look! This is the construction often used in animation, which is where I learned it during my brief stint at the Walt Disney Company. Many manga artists use animation drawing techniques like this, too.

Typical Head Shape

You could use this to construct a head for a young adult or even for children. The children's shoujo style will give you more childlike features, though.

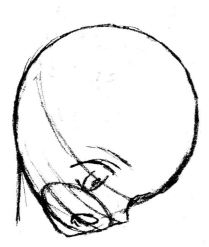

The Oval Placement Varies

This technique takes a little getting used to. You may need time to learn how to place the oval, depending on the turn of the head. No matter which way the head turns, draw the oval to fit in the area below the eyes and on top of the chin so it just reaches the outer edge of the eyes. Make the bottom curve of the oval sit right on or just below the bottom curve of the circle of the head.

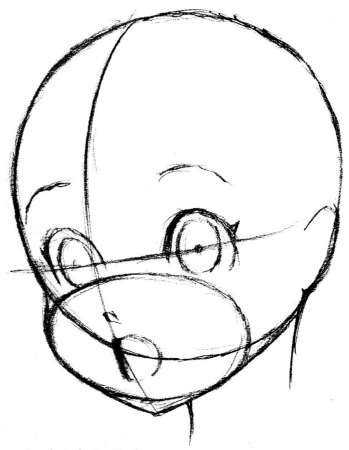

Practice Is the Best Teacher

Draw the face from every angle, with every kind of expression.

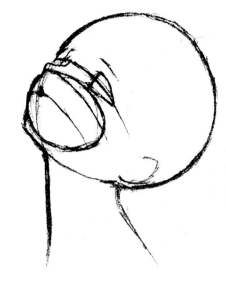

When you have practiced this technique enough, it will be second nature to you.

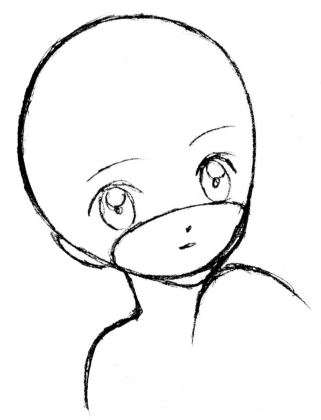

The Cheeks Vary, Too
The cheek area sometimes squashes or stretches depending on how the head is turned.

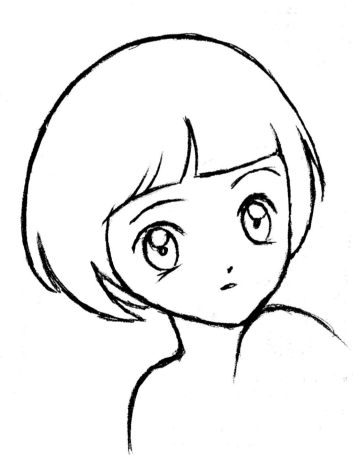

Long Bangs Become Expression
If your character has long bangs like this, raising or lowering the bangs will become a part of that character's expression. Here, the girl is surprised, so surprised that her bangs rode up and you can see her eyebrows!

The Figure

Drawing children or childlike characters, like the fairy here, is a skill you can use anywhere. This fairy is about 4½ heads high—much shorter than your average figure. But all the basic drawing rules still apply! Children can be as small as 2 heads tall (particularly chibi characters) or as tall as 6 heads, a measurement usually used for young teens. The children's style exudes sweetness and innocence. There is nothing harsh about this look. Sometimes characters may have pointy or spiky hair for effect, which only makes the soft, round contours of the faces and bodies look cuter.

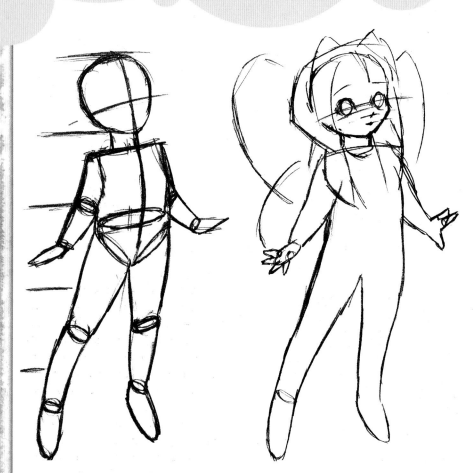

1 Some artists make children very willowy, so the stick figure is best for them, but I like to use the mannequin to get this plump look. This figure is about 4½ heads high, but appears 5 heads tall because she is on her toes. Leave all the guidelines in place until you are comfortable that the pose and construction are exactly how you want them.

2 Now that you have some idea of what you want to do, you can start erasing guidelines and tightening up your drawing. Add hair shape and some figure details.

3 Begin adding costume details. Leave your figure drawing underneath the costume until you are sure of your clothing shapes. Draw the sleeves like big, floppy ovals. They are shaped almost like pears. The sleeves and skirt are made of simple shapes like leaves. Make them out of loose triangles, one on top of the other.

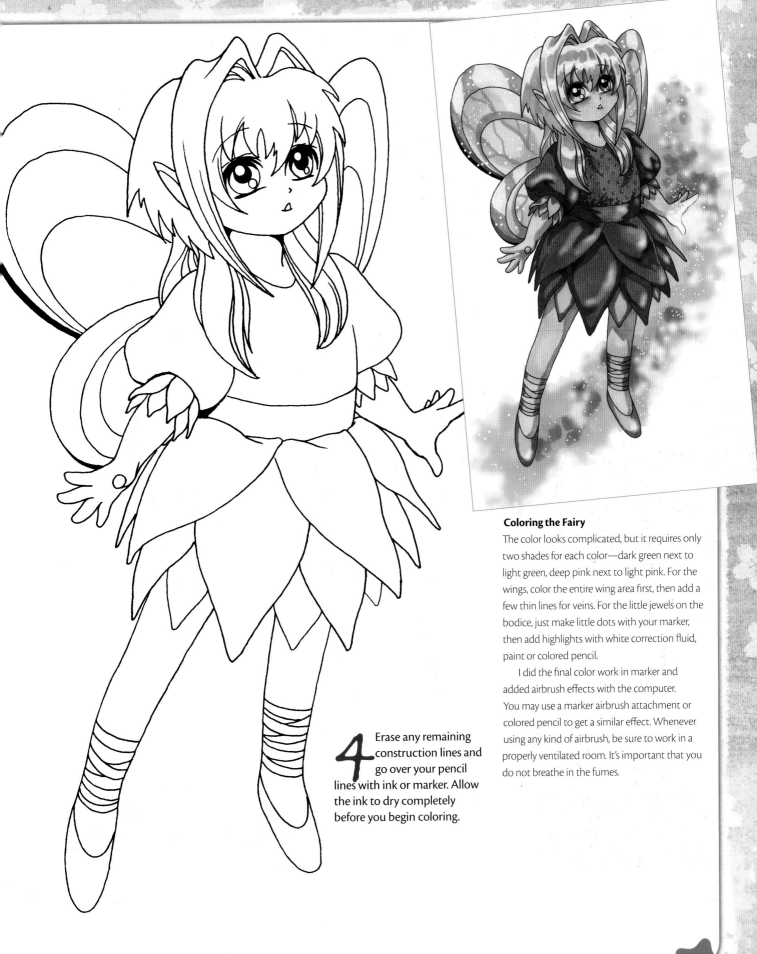

4 Erase any remaining construction lines and go over your pencil lines with ink or marker. Allow the ink to dry completely before you begin coloring.

Coloring the Fairy

The color looks complicated, but it requires only two shades for each color—dark green next to light green, deep pink next to light pink. For the wings, color the entire wing area first, then add a few thin lines for veins. For the little jewels on the bodice, just make little dots with your marker, then add highlights with white correction fluid, paint or colored pencil.

I did the final color work in marker and added airbrush effects with the computer. You may use a marker airbrush attachment or colored pencil to get a similar effect. Whenever using any kind of airbrush, be sure to work in a properly ventilated room. It's important that you do not breathe in the fumes.

THE AESTHETIC STYLE

This style is elegant and highly decorative. All line work is meticulous. There is nothing realistic about this look. The aesthetic style exists in a neverland of eternal, glacial beauty.

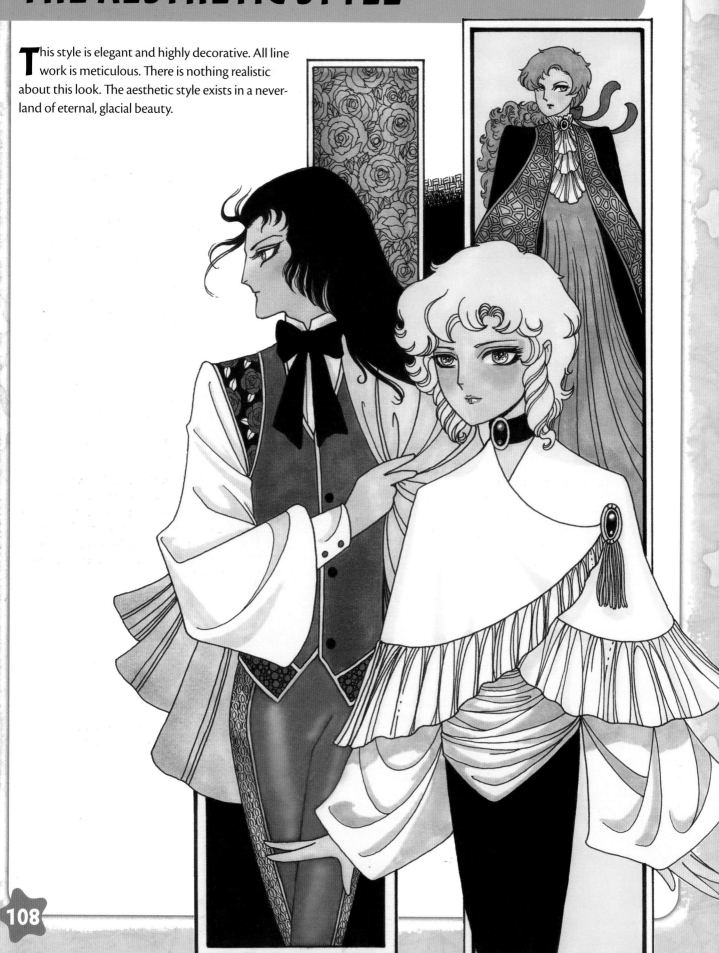

This style is so stiff and formal that in nearly one thousand pages of art, I found only a few variations on the front, profile and ¾-views.

FRONT VIEW

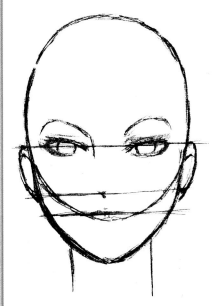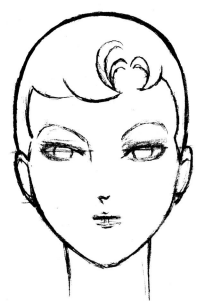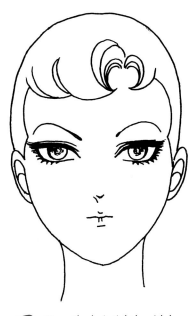

1 Draw the head as a perfect, lightly tapered oval. Do not ever use the triangular chin technique for this style. Except for extreme character types, men and women are always drawn with this head shape. Males and females are virtually indistinguishable.

2 Block in the features with care. From this angle, draw the nose as two tiny lines. Make these eyes flat and almond shaped.

3 Draw the hair tightly with lacquered precision. Hair is rarely drawn out of place. Draw the irises of the eyes using a series of tiny lines. This makes them sparkle. The mouth is quite small. Draw a couple of tiny creases in the lower lip.

The nose shown in front and ¾-views.

The mouth is subtly drawn, very small and does not have a wide range of expression.

PROFILE

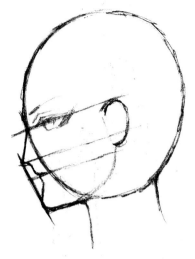 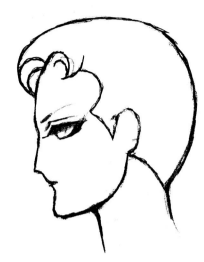 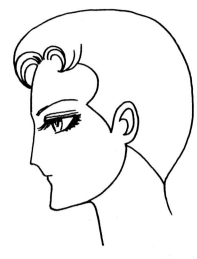

1 Draw the nose and mouth at an angle jutting out from the head. The nose and chin should be on the same line.

2 The mouth is almost invisible in profile. The nose is perfectly straight. Draw the hairline so it almost meets the eyebrow.

3 There is no other manga style of which I am aware that draws the eye in this way. It is very stiff with a series of tiny lines over the upper lid and almost all lashes drawn on the bottom and side of the eye, instead of on the upper lid.

3/4-VIEW

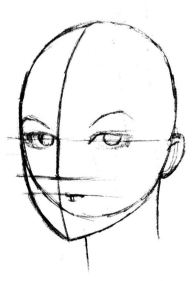 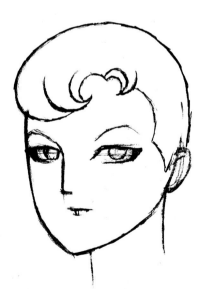 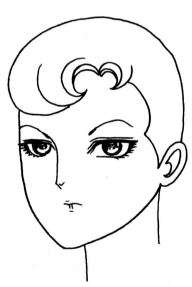

1 Draw the ¾-view as an off-center oval. Keep the line of the face very clean.

2 Draw the nose as a perfectly straight line. Add a tiny shadow line at the very tip. Even though real eyes move around the head, for this style, draw them almost flat no matter which way they turn.

3 Draw the mouth off center, inside the line of the nose. Make it very small.

 he aesthetic figure is tall and slim, but it has solid form.

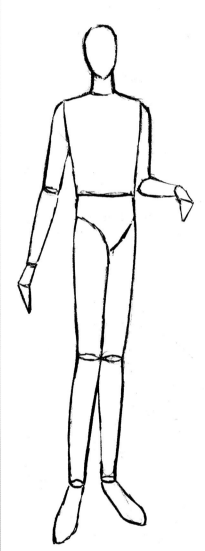

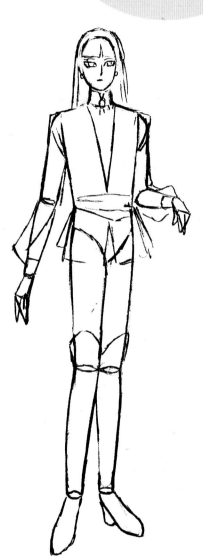

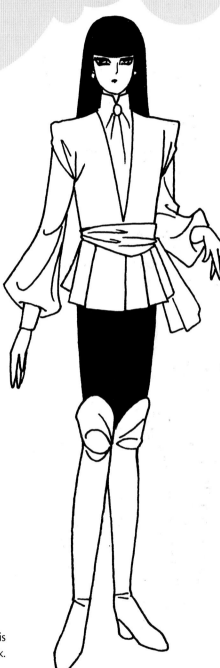

1 Use the mannequin technique for the basic form. This style has a solid-looking base. The perfectly clean ink lines of your final drawing look best if the underlying form of the drawing has a sense of roundness.

2 Unlike most manga styles, there is nothing fluid about the line work. Make the forms stiff and formal. Draw figures and folds of clothing with mechanical precision. Make the folds as simple as possible. Do not add loose lines the way you did in the contemporary style (chapter 1). Draw all folds as long C-curves, clean ellipses or simple parallel lines.

3 Draw all ink lines as crisply as possible. Never use loose line work with this style. Figures never have naturalistic poses. Capture them in photo-perfect moments.

Backgrounds and decoration are characterized by a bold use of black and white, and embellished with complex hatching techniques. The only realistically drawn elements ever seen in this style are the roses that occasionally pop up. Everything else—buildings, chairs, walls, you name it—are subjected to extreme stylization.

None of these hatching decorations are difficult, but all are time-consuming. You can get a lot of interesting effects out of these techniques and you can also make up your own. They are more beautiful and interesting than mechanical effects or tone sheets. The aesthetic style almost never uses mechanical tones. All is drawn in clean, graphic black and white.

Eight-Pointed Star

Add tiny drops of ink to the ends of this star to give it a twinkle. This pops up in backgrounds to symbolize romantic fascination or any bedazzled state of mind.

White Roses

Cleanly rendered white roses on a stark black background makes a great backdrop behind a simply rendered white figure. Add a few drops of white correction fluid to give a sense of dewy freshness or to indicate stars.

Hatching

The hatching technique works everywhere in this style—on buildings, clouds, even on curtains—as seen here. For dark areas, build up the hatches by overlaying the strokes of your pen. Keep all other pen strokes very clean. Let the lines break up as you round the form. This is an interesting look, especially when combined with the stark foreground figures commonly used in the aesthetic style.

DECORATION

Decor
Small circles of varying sizes, crowded together work on walls, picture frames or anywhere you want to create a graphic decorative sense.

KEEP EXPRESSION TO A MINIMUM IN AESTHETIC SHOUJO

Except for comic effect, broad expressions are rarely used in this style. This is one of the few expressions used. Note that the inside of the mouth is drawn with hatching lines instead of solid black.

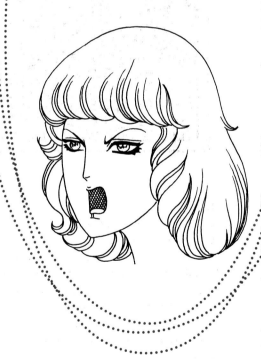

Foggy Strokes
Tiny pen strokes, built over one another in different directions indicate clouds and fog, or symbolize a dazed mind. Twist and wind them into wavy shapes.

Feathery Backgrounds and Lace
Draw these light feathering shapes as two little strokes facing one another. Build up the lines to create dark areas, break up the lines for light. Use for background decoration or even for lace effects on clothes.

THE MODERN STYLE

Simplicity, minimalism, bold use of negative space and naturalistic figure drawing characterize this style. We reviewed how to draw the modern style body type on pages 52–55, but the characteristics of this face type are quite unusual and unlike most other manga styles.

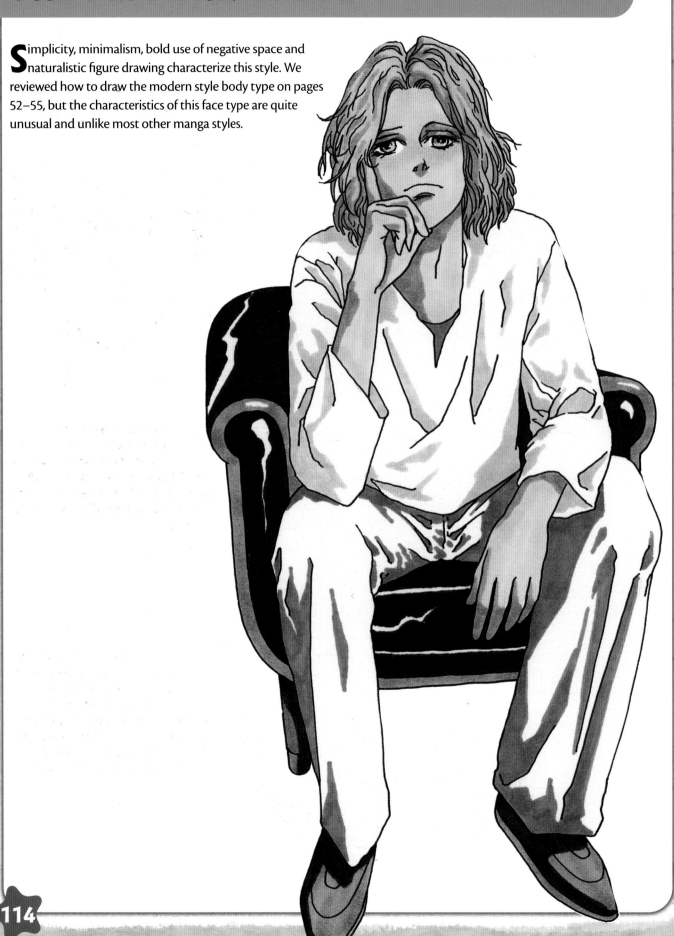

Female Heads and Faces

FRONT VIEW

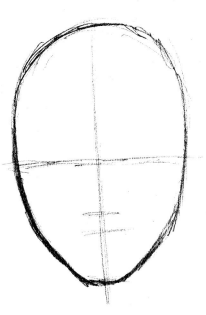

1 This face type uses the oval shape commonly seen in academic drawing.

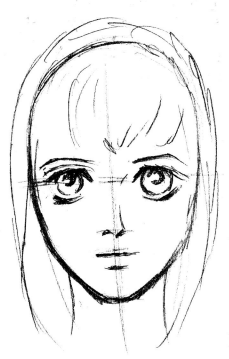

2 Place the eyes in the middle line of the head. Place the nose halfway down from there and the mouth halfway down from there. Make the eyes large and expressive. Draw the chin so it is slightly squared off. Do not make it pointed.

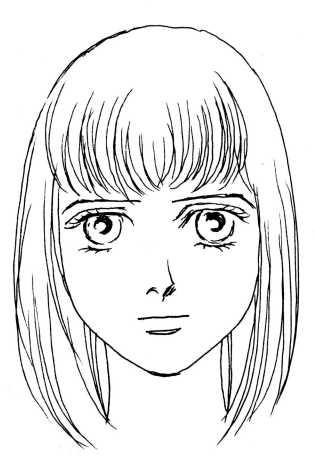

3 A unique feature of this style is the inking technique. Ink the face with loose strokes. Use several short lines instead of a solid line to shade the bottom of the nose. Draw the eyes with small strokes as well. Ink the eye as a series of small dashes of line. Use dashes of line for the hair, too. Keep all your lines very free.

PROFILE

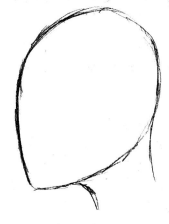
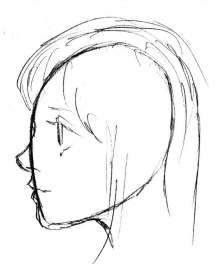
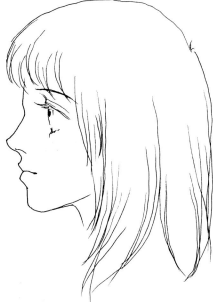

1 Begin with a tilted egg shape.

2 Make the nose upswept with a large nostril. The eyes are a series of lines.

3 Use loose, delicate strokes for hair. Draw just the barest hint of the iris and pupil. Leave much of the eye blank. Do not darken eyelashes. Ink them as a series of lines so they appear blonde. This technique is used even on dark-haired characters. Give the chin a squared-off line. Make the lower lip more prominent than the upper lip.

3/4-VIEW

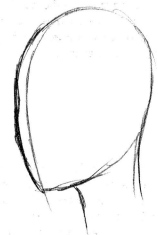
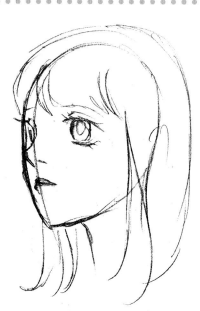
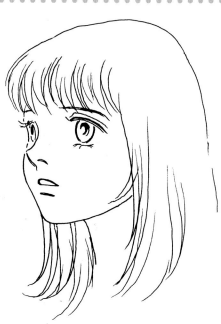

1 Draw an off-center oval.

2 The placement of the nose and mouth are important for this look. Unlike most manga styles, this style gives the face an underbite. The lower lip juts out. The nose is not smooth or small, but has a large nostril and an upsweeping shape.

3 Draw the mouth as a line that forces the lower lip and chin to protrude. Ink the eyes with broken lines. Draw the far eye but do not enclose the line. Make the cheek rounded.

Male Heads and Faces

This is one of the few shoujo styles where you will have no trouble telling the difference between the girls and the boys!

FRONT VIEW

1 Draw a strong, oval shape with a squared-off chin. Place the facial features as you would the features in the female head.

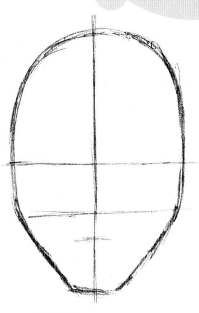

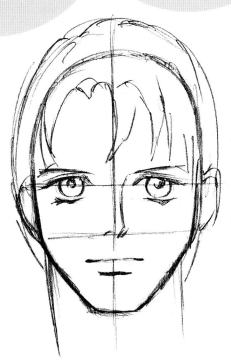

2 Draw the male jaw with a firm, high angle. Make the mouth wide, as wide or wider than the chin. Draw the eyes narrower than the girl's and angle them downward.

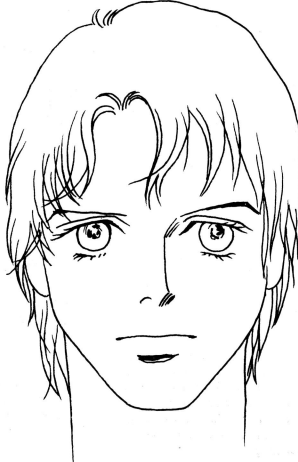

3 Draw the eyebrows so that the highest point is at the outer edge of the eyes. Ink the hair in loose strokes. Do not let the lower lashes touch the iris. Ink the shadow around the nose and bottom lip with a series of short, loose lines.

PROFILE

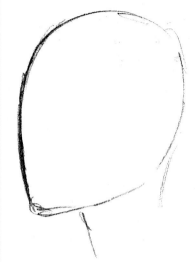 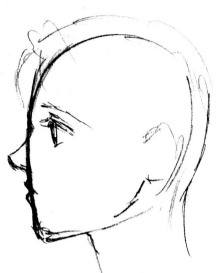 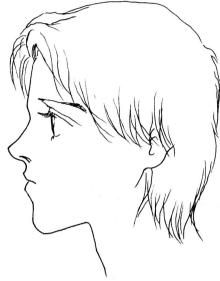

1 Draw an oval for the profile.

2 This style always gives the face an underbite and a squared-off chin. The nostril is quite prominent.

3 Draw the eyebrow so that the arch is at the outer edge of the eye. Make the lashes prominent on the upper lid, but very delicate on the lower lid. The iris is merely suggested from this angle. Unlike other manga styles, the far side eyelashes are not seen in profile.

3/4-VIEW

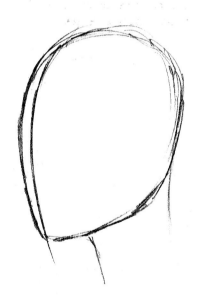 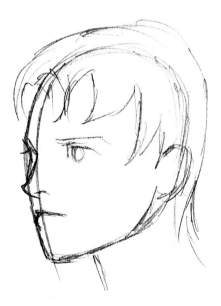 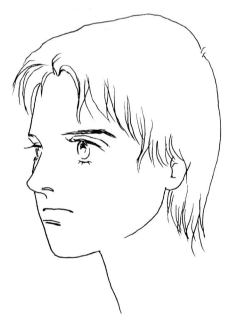

1 The ¾-view oval is the same shape as the female's, but with a stronger chin.

2 Place the features as you would in the female head, but do not give the male face soft, rounded cheeks. The outer edge of the male head is smooth. Do not point the chin.

3 Ink the hair loosely. Eyebrows, nose and mouth are inked using a series of small lines. Do not use heavy blacks in this style.

This style often uses splashes of color instead of fully painted color to make a graphic statement. Practice here using the front view drawings.

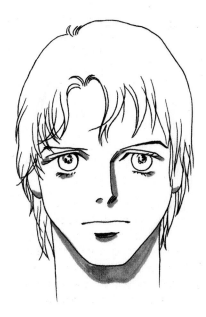 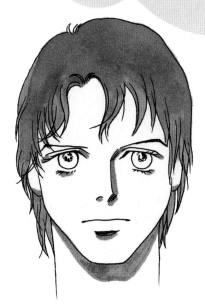 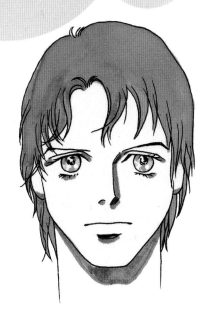

1 Shade in a few areas of the face with a sepia tone or light brown. Under the chin, around the nose and about the eyes are the best places.

2 Use a flat color for the hair. Do not add highlights.

3 Color the eyes with three shades of blue. By using minimal, muted colors everywhere but on the eye, your own eyes concentrate on the character's intense blue gaze.

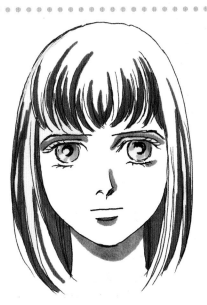 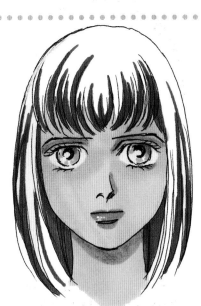

1 Another way to use color in this style is to leave large areas of the hair completely blank. Color only some strands of the hair in a bright orange.

2 Color the entire face in a pale pink tone, but add lipstick and highlights to the mouth. The modern style pushes the pout.

119

THE ILLUSTRATIVE STYLE

This elaborate style comes the closest to the western comics look. Figures are constructed very much the same way they are in western art, but the use of line and the decorative sensibility of this look is Japanese. This is the hardest to master of the manga styles, but it is very beautiful. Everything in this style is centered around creating highly decorative images. Sometimes the manga are so densely drawn that they are hard to read! Storytelling sensibility is secondary to the lovely pictures.

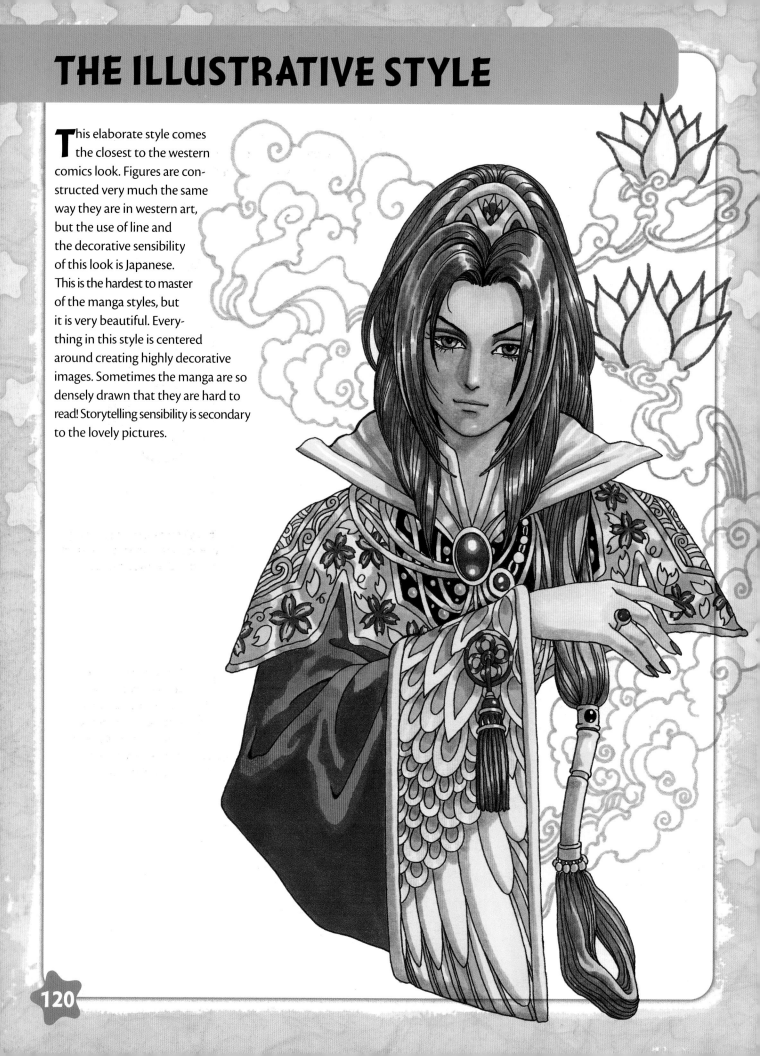

The illustrative style also uses a purely oval-shaped head, the same kind used to construct a head using the academic technique. The location of the features is also the same, though the face may be drawn slightly longer and thinner for males, and slightly fuller for females.

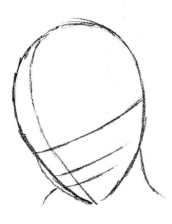

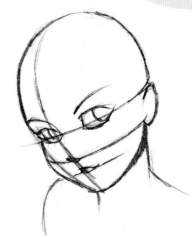

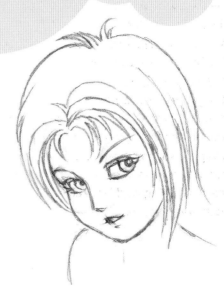

1 Begin with the oval and draw your guidelines for the facial features.

2 The eyes are located at the midpoint on the head, the nose halfway down from that, and the mouth halfway down from the nose.

3 Though the face still has a manga look, it also has more of a sense of structure than most manga faces.

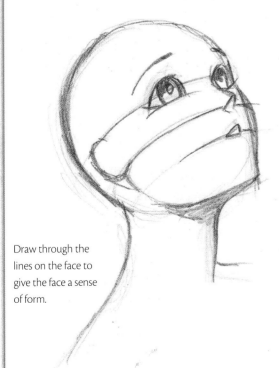

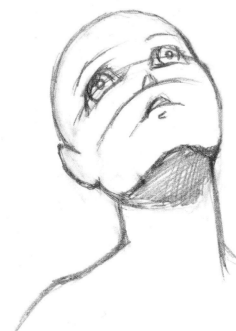

In most manga styles, the jawline is left blank when the head looks up. In this style, the form of the head is maintained at all times. A strong shadow under the jaw and chin helps establish the form.

Draw through the lines on the face to give the face a sense of form.

121

The Figure—Kabuki Lion Dancer

Now that you have had a lot of practice drawing different shoujo styles, you are ready to take on the challenge of the more difficult and complex illustrative style. The illustrative style requires a little more planning and careful drawing than other styles. Let's try an action pose with some more complicated decoration to really get the look of this style. The important thing is to capture the graceful sense of line and combine it with a more western sense of realism in the face and figure.

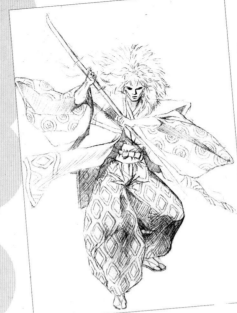

Preliminary Sketches

Before you sit down to create a complicated picture, make a preliminary sketch. This is an older sketch I did that I never used. I like the idea of a lion dancer picture in the Kabuki-style kimono, but the outfit is wrong and the drawing style too western. Let's give it another try.

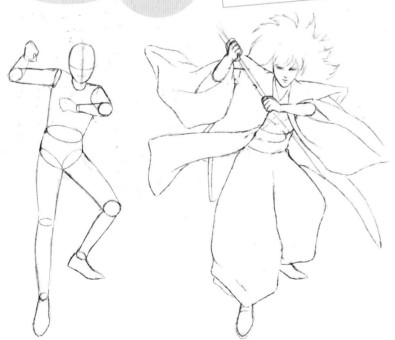

1 Use the mannequin technique for the base of your drawing. The mannequin technique results in a more realistic figure with a greater sense of form. You need that form in this style to give your bodies a more accurate base for their clothes and to make their movements more real.

2 Most of the figure is going to be hidden by those robes, so don't spend too much time with details. Draw the flowing robes in great sweeping shapes over the simple mannequin form. Kabuki lion dancers have big, 1980s wild hair! Go crazy with its shape.

3 Tighten up the drawing and erase all guidelines. The face in this style is delicate. Draw it in a very similar way to the romantic hero on page 44. The biggest differences between this head and the head on page 44 are the slightly smaller eyes and the more oval face shape. Create a slightly pointed chin and almond eyes. Do not exaggerate the facial features. Inking in this style requires a deft hand, so keep your drawing clean so you don't follow the wrong sketch lines.

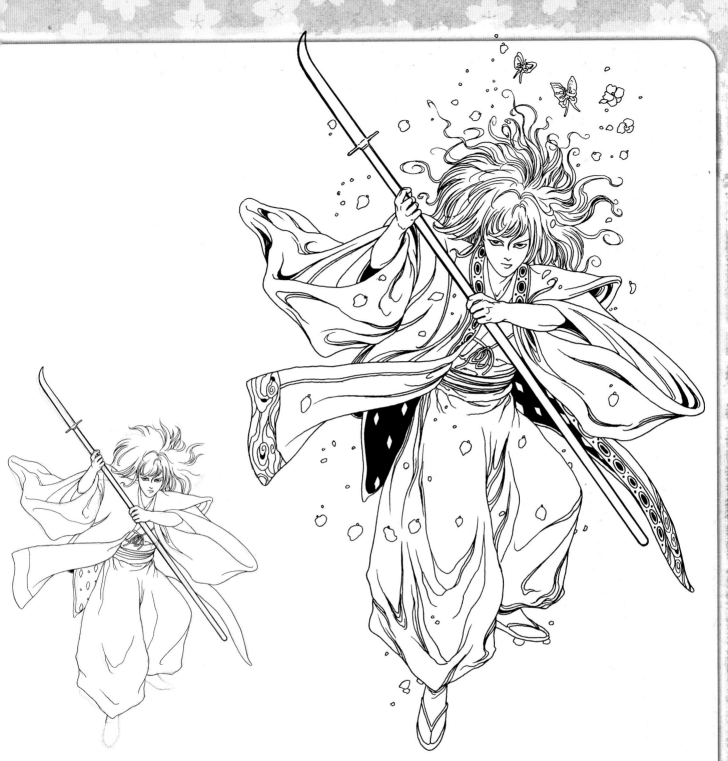

4 Draw through the lines on the handle of the weapon so it is easier to make the hands into fists around it. Keep ink lines very graceful and smooth. Half the pleasure of this style is in the line quality. Parallel lines that sweep around the contours of the clothes and hair give the shapes mass.

5 Add decoration to the robes. You can be as outlandish with the decoration as you like, but I did not want to obscure the line work here, so I kept it simple. There's no magic formula for drawing this kind of line. It takes practice. It's best accomplished with a pen, not a brush.

Falling cherry blossom petals symbolize the ephemeral quality of life, an appropriate touch for this picture. Butterflies are sometimes used in both eastern and western art to symbolize the soul.

FINAL WORDS

Thank you for taking the time to read this book. I have enjoyed shoujo manga for many years, and I have learned a great deal from the masters of the form. I hope that I have successfully passed on to you some of what I have learned.

My greatest respect is reserved for the artists Junko Mizuno, Riyoko Ikeda, Ayumi Kasai, Uchimi Yoshida, Yasuko Aoike, Minako Narita and Mineo Maya, all of whom were great influences on me and were used as references for this book. Thank you also to Fred Schodt for introductions and for inspiration.

Though this book concentrates primarily on the style of shoujo drawing, it is very important for you as an artist to create your own look and follow your own path. While respecting and learning from the masters of manga art, find your own voice and sing.

Years ago, when I was in Tokyo for the Japan/U.S. manga seminar, I discovered tone sheets that artists could use to create instant backgrounds. I was amazed that so many were available and that a professional manga artist did not have to draw time-consuming backgrounds at all. I wondered briefly if I should chuck all of my background work and use tone sheets forever!

But Takeyuki Matsutani, the president of Tezuka Productions, shook his head and said to me, "Go your own way." Though it would be easy to copy another artist's work and have all my backgrounds drawn for me (and at the time, almost no one in the USA used them), here was this man from the most important company in Japan, who had worked with the most important manga artist in history, telling me "Go your own way." If there is something you like about manga or manga techniques, it is fine to study it. But it is also very important to find new ways of doing things, new ways of drawing, new ways of telling a story, and to combine influences from many different kinds of art.

The best manga artists don't look at manga alone. They look at work from all over the world. They study, they innovate. A true artist is a creator who creates new images and ideas. Enjoy manga and enjoy drawing in the manga style. But also, strive to draw in the style that will become all yours.

As Mr. Matsutani said, "Go your own way."

Some Resources

BOOKS ON COMICS

Many books for creating manga are meant for Japanese audiences; a lot of the information doesn't apply to OELs (Original English Language manga). American publishers have different styles and submission guidelines than Japanese publishers and that includes Japanese publishers with American offices, such as Tokyopop. So becoming familiar with U.S. methods is essential. Below are some titles you might find useful.

≋✿ *The DC Comics Guide to Coloring and Lettering*, by Mark Chiarello and Todd Klein (Watson-Guptill, 2004).

≋✿ *Writing for Comics With Peter David*, (IMPACT Books, 2006). Great for script-writing.

≋✿ *Graphic Storytelling and Visual Narrative* and *Comics and Sequential Art*, both by Will Eisner (Poorhouse Press, 1996, 1985). Essential for any comics library.

≋✿ *Understanding Comics* and *Reinventing Comics: How Imagination and Technology Are Revolutionizing an Art Form*, both by Scott McCloud (Harper Paperbacks, 1994, 2000).

≋✿ *Manga! Manga!: The World of Japanese Comics* (Kodansha America, 1988) and *Dreamland Japan* (Stone Bridge Press, 1996) by Fred Schodt. Essential works on manga and its history.

≋✿ *Comic Artist's Photo Reference: People and Poses*, by Buddy Scalera (IMPACT Books, 2006). Extensive primer on using photos in your art. There are more than 1,000 photos for you to reference and practice with in this handy book/CD combination.

≋✿ *Perspective for Interior Designers*, by John Pile (Watson-Guptill, 1989).

OEL PUBLISHERS

Most American publishers of comics and graphic novels now publish OEL. Don't limit your submissions to Japanese publishers. Submit directly to an editor at a convention, if you can. And many publishers have websites and publish their submission guidelines online. Here are just a few:

www.tokyopop.com

www.antarctic-press.com

www.darkhorse.com

www.wirepop.com

www.imagecomics.com

www.papercutz.com

INDEX

Adult women's comics, 7, 91
Aesthetic style, 91, 108–113
 background and decoration in, 112
 figure in, 111
 heads and faces in, 109–110
Aoike, Yasuko, 124

Brushes, 10
Butterflies, 123

Candy, Candy, 91
Cherry blossom petals, 123
Children's style, 91, 102–107
 figure in, 106–107
 heads and faces in, 103
Chin
 child, 19
 male, in classic style, 95
 Shoujo girl, 38, 42
 3/4-view, 33
Chrysanthemum, 77
Cinderella (Mizuno), 91
Circle, 12
CLAMP, 91
Classic style, 91–97
 female Shoujo in, 93, 96–97
 male Shoujo in, 94–95
Clothing
 details with, 60
 for elves, 59
 feminine, 55
 folds in, 65–66. See also Folds
 free-flowing, 56–57
 kabuki lion dancer, 122–123
 kimono, 76–79
 for modern-style male, 53
 romantic, 80–81
 transparent cloth, 75
 See also Costumes
CMX Manga, 91
Color
 minimalism, modern style and, 119
 monochromatic scheme, 74
 for small drawings, 55
 smooth areas of, 44
 vibrant, 79
Contemporary style, 56–57, 91
Correction fluid, 11
Costumes
 complex, 74

fantasy, 72
historical, 70–71
Japan's national, 76–79
ruffles and flourishes on, 80–81
Western, 80–81
See also Clothing
Crane motif, 77
Crests, 77
Crow quill pen, 10, 45
Crying, 30–31
Cylinder, 12

Deep Love, 6
Deleter marker, 10, 45, 53
Depth, creating, 74
"Drawing through," 48–49, 51

Eight-pointed star, 112
Elves, 59
Erasers, 10
Expression
 on aesthetic-style Shoujo, 113
 eyes and, 23–25, 29
Eyelet lace, 80–81. See also Lace
Eyes
 blind or entranced, 27
 bloodshot, 27
 cat's eye slit, 27
 children's, 19
 construction of human, 20
 demonic, 27
 expression and, 23–25
 eyeball, 20
 eyelashes, 39
 eyelids, 20
 jelly bean, 28–29
 magic or power, 27
 narrowed, 24
 otherworldly color, 29
 profile, 22
 Shoujo, 21
 smiley, 24
 sneaky, 23
squinty, 24
 starburst, 26
 starlight, 26
 supernatural look, 27
 surprise, 23
 tears in, 30–31

Face, 13. See also Head
Fairy, 106–107
Fans, 77
Fantasy costumes, 72
Feathery backgrounds, 113
Female. See Shoujo female
Figure. See Human figure
Folds
 diaper, 65
 drop, 65
 halflock, 65
 inert, 65, 74
 movement of clothing and, 67–69
 pipe, 65
 seven basic, 65–66
 spiral, 65
 zigzag, 65, 74

Geisha, 76
Girls
 comics for young, 7
 See also Shoujo female, girl
Gloves, 80–81
"God of Comics," 6, 7
G-pen, 10, 45

Hair
 basic, 82
 children's bangs, 105
 coloring, 86–87
 curly or wavy, 84
 current hairstyles, 87
 girlish, 55
 long, beautiful, 88–89
 spiky, 82–84
 wildly colored, 40, 42
Hands, 62–63
Hatching technique, 112
Head, 15–46
 adult men, 18, 32
 adult women, 18
 in aesthetic style, 109–110
 basic construction, 16–17
 boy's, 19
 in children's style, 103–105
 in classic style, 93–95
 eyes in. See Eyes
 girl's, 19
 in illustrative style, 121
 in modern style, 115–118

older teens, 18
in retro style, 99
young child's, 19
Historical costumes, 70–71
Human figure
in aesthetic style, 111
body sketches, 50–51
in children's style, 106–107
in contemporary style, 56–57
drawing, 47–48
height of standard, 12–13
in illustrative style, 122–123
in retro style, 100–101
of Shoujo female, 54–55
of Shoujo male, 52–53
See also Stick figure
Ikeda, Riyoko, 124
Illustrative style, 91, 120–123
figure in, 122–123
head in, 121
Ink, 10

Josei manga, 7, 91

Kabuki lion dancer, 122–123
Kasai, Ayumi, 124
Kimba the White Lion, 7
Kimono, 76–79
Kodomo manga, 7, 102. *See also*
Children's style

Lace, 80–81, 113
Legs, long, 51
Lion King, The, 7

Male. *See* Shoujo male
Manga-ka, 6
Mannequin form, 47–49
Mannequin technique, 122
Marker, 10–11
adding colors with, 53
airbrush, 44
blender, 11, 44
Deleter, 10, 45, 53
Matsutani, Takeyuki, 6, 124
Maya, Mineo, 91, 124
Mizuno, Junko, 91, 124
Modern style, 91, 114–119
color minimalism and, 119
female Shoujo in, 54–55

male Shoujo in, 53
heads in, 115–118

Narita, Minako, 124

Obi belt, 77
OEL (Original English Language manga),
6

Paper, 10–11
Pencils, 10
Pens, 10–11
Portfolio, 11
Princess Knight, 7
Profile
in aesthetic style, 110
in classic style, 93, 95
eye, 22
hand in, 63
in modern style, 116, 118
Shoujo female in, 38
Shoujo male in, 32

References, 58–61
Retro style, 91, 98–101
accessories in, 101
figure in, 100–101
heads and faces in, 99
Ribbons, 97
Ribon no Kishi, 7
Romantic clothing, 80–81. *See also* Clas-
sic style
Romantic hero, 44–46
Rose of Versailles, The, 91
Roses, white, 112
Ruffles, 80–81, 97

Sandals, 77
Schodt, Fred, 124
Shadows, color in, 74–75
Shapes, basic, 12
Shoujo female
in classic style, 93, 96–97
contemporary figure, 56–57
figure of, 54–55
girl, 38, 40–43
skipping pose, 56–57
3/4-view head, down shot, 39
Shoujo male
in classic style, 94–95

boy, 36–37
figure of, 52–53
kimono for, 77
modern style, 53
profile of, 32
romantic hero, 44–46
3/4-view down, 34
3/4-view straight, 35
3/4-view up, 33
Shoujo manga, meanings of term, 7
Shoujo styles, 91
aesthetic, 91, 108–113
children's, 91, 102–107
classic, 91–97
contemporary, 56–5791
illustrative, 91, 120–123
modern, 91, 114–119
retro, 91, 98–101
Shueisha, 91
Socks, 77
Square, 12
Stick figure, 47–50
Shoujo female, 54, 56, 96
Shoujo male, 52–53
Swan (CMX Manga), 91

Templates, 11
Tezuka, Osamu, 6, 7 (still on page 6?)
3/4-view
in aesthetic style, 110
in classic style, 93, 95
jelly bean eye, 28–29
in modern style, 116, 118
in retro style, 99
Shoujo female, 39
Shoujo male, 33–35
tears, 31
Triangle, 12

Vambraces, 59

Western artists, 50
Western costume, 80–81
White roses, 112

Yoshi, 6
Yoshida, Uchimi, 124

IF YOU'RE GOING TO DRAW—
DRAW WITH *IMPACT*

Look for these and other great IMPACT books at your local art, book or comic book store. Or visit our website at www.impact-books.com.

Discover the secrets to drawing manga and have fun doing it as you create dozens of characters in a variety of costumes. The easy lessons in this book make drawing in the world's most popular style as easy as picking up a pencil.

ISBN-13: 978-1-58180-697-7, ISBN-10: 1-58180-697-3, PAPERBACK, 96 PAGES, #33356

Manga Fantasy Madness provides over 50 easy-to-follow dynamic demonstrations in pencil, colored pencil, and markers. Follow along with the hundreds of action-packed illustrations of popular manga fantasy characters such as knights, wizards, elves, princesses and more for easy reference and idea generation.

ISBN-13: 978-1-58180-708-0, ISBN-10: 1-58180-708-2, PAPERBACK, 128 PAGES, #33374

This book features tons of quick lessons with step-by-step instructions for drawing people, creatures, places and backgrounds. Lea Hernandez is one of Manga's most popular artists, and this book is filled with hundreds of her illustrations that will inspire you to draw your own comics. Perfect for beginning and advanced artists.

ISBN-13: 978-1-58180-572-7, ISBN-10: 1-58180-572-1, PAPERBACK, 112 PAGES, #33029